MAN WITH A BLUE SCARF

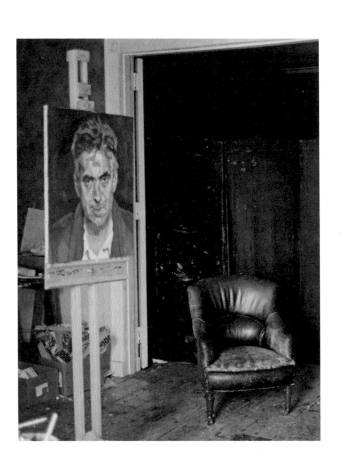

MAN WITH A BLUE SCARF

On Sitting for a Portrait by Lucian Freud

Martin Gayford

with 64 illustrations, 58 in color

First published in 2010 in hardcover in the United States
of America by Thames & Hudson Inc., 500 Fifth Avenue,
New York, New York 10110

thamesandhudsonusa.com

Library of Congress Catalog Card Number 2010923357

ISBN 978-0-500-23875-2

Printed and bound in China by C&C Offset Printing Co. Ltd

CONTENTS

MAN WITH A BLUE SCARF
THE SITTINGS

Author's Note

The following is based on a diary I kept during the year and a half in which I sat for two portraits, one in oils, one etched. Some conversations and events I have omitted, in places I have amplified my thoughts of five years ago, a few exchanges and incidents have been moved a little in time to assist the narrative flow, but essentially what follows is a record of what happened in the studio.

L ucian Freud indicates a low leather chair and I sit down. 'Does that pose seem reasonably natural?' he asks. 'I try to impose my ideas on my sitters as little as possible.' It's a cold late autumn day and I am wearing a tweed jacket and a royal blue scarf. Perhaps, I suggest, I could keep the scarf on for the picture. LF agrees, but on certain points it soon turns out his will is law. I had thought that perhaps I could read while sitting, and had brought a book along with me, but no. 'I don't think I'm going to allow you to do that. I already see other possibilities.' He must have registered them almost instantly.

At this point LF makes chalk marks on the floorboards around the legs of the chair. This is so that we can replace it in precisely the same position with reference to the overhead light and the easel each time I come to the studio. Behind, LF positions a battered black folding screen: the backdrop to my head. Then he searches around for a suitably sized canvas among the various ones leaning against the studio wall. The first he finds is discarded as it has a dent, which he says would sooner or later cause the paint to flake off. Then he fishes another out of the corner and sets to work immediately, drawing in charcoal.

So it begins. This is how hour after hour will be spent, stretching for months into the future. Sitting in a pool of light in the dark studio, I start to muse and to observe.

...

I have long been convinced that Lucian Freud is the real thing: a truly great painter living among us. When, one afternoon

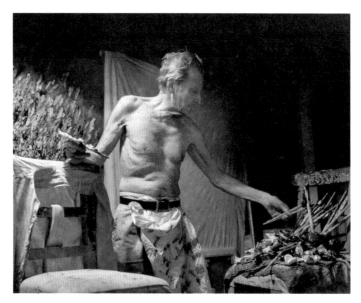

Lucian Freud, 2005

over tea, I – very tentatively – mentioned to him that if he wanted to paint me I would be able to find the time to sit, my motive was partly the standard one of portrait sitters: an assertion of my own existence. For various reasons, I was feeling rather down and being painted by LF seemed a good way to push back against circumstances.

The other reason was a curiosity to see how it was done. After years of writing, talking and thinking about art, I was attracted by the prospect of watching a painting grow; being on the inside of the process. Even so, when I made that modest proposal, I didn't really expect LF to accept. Probably, I thought, he would say something politely noncommittal along the lines of, 'That's a nice idea, perhaps one day.' Instead, he responded by saying, 'Could you manage an evening next week?'

I had known him for quite some time before that day, getting on for a decade. We had talked for many hours as friends, and as artist and critic. I had eaten innumerable meals in his company; together we had visited exhibitions and listened to jazz concerts. Dozens of times I had visited his studios, to look at recently finished pictures and work in progress. This, however, was different. This time, I was not looking at the picture, but *being* it – or at least its starting point.

...

The experience of posing seems somewhere between transcendental meditation and a visit to the barber's. There is a rather pleasant feeling of concentrating and being alert, but no other need to do anything at all except respond to certain requests: 'Would you mind moving your head just a little?', 'Could you move the scarf just an inch? As it is, it looks a little bit

"dressed".' At moments sitting seems an almost embarrassingly physical affair: an enterprise that concerns the model's skin, muscles, flesh and also, I suppose – if there is such a thing – self.

I ask if talking is allowed while I'm posing, and LF says it is, 'although I may sound like an absolute lunatic'. In practice, we alternate between conversation and periods when his concentration is intense. During those he keeps up a constant dance-like movement, stepping sideways, peering at me intently, measuring with the charcoal. He holds it upright, and with a characteristic motion moves it through an arc, then back to the canvas to put in another stroke. During this process he mutters to himself from time to time, little remarks that are sometimes difficult to catch: 'No, that's not it', 'Yes, a little', 'Slightly ...' At intervals he takes a wad of cotton wool from his pocket and wipes a stroke or two away. Once or twice he steps back and surveys what he has done, with his head on one side.

...

Lucian Freud has been at work for a long, long time. He was born in Berlin in December 1922. From boyhood he always intended to become a painter. His earliest surviving oil paintings date from the 1930s, by which time his family was living in England. But despite the fact that his career now stretches over six decades, it would be wrong to claim that his art is simply the continuation of a great tradition: the depiction of people, things and places from life.

It is closer to the truth to say that by an act of will and daring he revived the figurative tradition, and did so with immense conviction. Even in his youth there were many people who said that kind of figurative painting was dead.

He arrived on the scene long after Marcel Duchamp had pioneered art based on found and altered objects, rather than painting or drawing. Piet Mondrian, Wassily Kandinsky, Jackson Pollock and Mark Rothko were all much older than him. He worked in the era of pop art, op art, land art, performance art and many another avant-garde movement.

At primary school, in Germany in the 1920s, Freud was taught how to do up his shoes in a certain manner. 'So,' he remembered eight decades later, 'I immediately thought I'll never tie them *that* way again.' It was an entirely characteristic reaction. To be told he must do something, he has admitted, is enough to make him want to do something different. His unwillingness to follow the rules laid down has extended from fastening footwear to flouting the alleged dictats of art history.

Long ago, in reply to prognostications that his kind of painting – which for want of a better word I'll call naturalistic – was 'impossible', or 'irrelevant', 'after Cézanne', or 'after Duchamp' (art critics used to like to lay down these laws), LF said: 'I would have thought that the fact that something was forbidden, or almost illegal, would make it all the more exciting.'

. . .

After about an hour, he suddenly flops down on a pile of rags in the corner, and asks if I want to stretch my legs. I take a look at the image that is just beginning to appear on the blank, white canvas. A glance at this charcoal drawing suggests he is planning an over life-size close-up of my head.

To pose for this, I wonder, will I have to cross my legs the same way every time? The answer is yes. LF says that weight and balance are affected by the position of the legs. So I am to

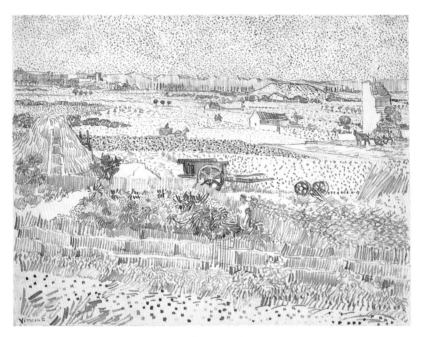

Vincent van Gogh, *Harvest in Provence*, 1888

spend dozens, maybe hundreds, of hours, with my right leg crossed over my left, and not the other way round.

How, I ask, does he decide to compose a picture?

'I try to do something as little like what I have just done as possible. My ideal response from someone who saw a new work would be: "Oh, I didn't realize that was by you."'

We look at some drawings by Van Gogh, from the book I brought thinking I might pose as a reader. LF enthuses about one of an extensive landscape looking over the Crau, the plain outside Arles where Vincent often walked (p. 12). 'Many people would say that this is derived from Japanese art, but I would happily exchange every Japanese landscape of the nineteenth century for this. It has such a wonderful sense of the earth, not just extending away towards the horizon, but also its curvature, its roundness.'

'Being able to draw well', he goes on, 'is the hardest thing – far harder than painting, as one can easily see from the fact that there are so few great draughtsmen compared to the number of great painters – Ingres, Degas, just a few.'

LF adds of his old friend and, at one stage, sitter, Francis Bacon: 'He constantly doodled, I wouldn't call it drawing but there was something of him in it. His best paintings were done so entirely by inspiration that there is almost no basis of drawing. With Sickert, for example, even when his pictures are not so good there is an underlying drawing that keeps them at a certain level. With Bacon it's just not there.'

Then the conversation skips sideways, on a slight tangent. 'I had a Max Ernst painting once. I persuaded my father to buy it for me when I was twenty-six. It was of a flower, on a background of beautiful green paint. In the end I got tired of it, I think because Ernst didn't know how to draw. In a way, it

wasn't the sort of picture that required a lot of drawing, but I feel you would know whether somebody could draw or not from a footprint. What is very lively and imaginative about him is his collages, *Une Semaine de Bonté*. Once in Paris I went to a dinner party with Max Ernst, Man Ray and his wife.'

'Was it fun?'

'No, I remember wondering afterwards why it hadn't been more fun than it was. I think it was to do with Ernst himself. Somehow the whole occasion was awkward. Man Ray was very noisy and vulgar – I liked him. But Ernst, though in a very Parisian manner, was still rather German. The French, when they are malevolent – which is often – are so in a way that is observant, witty and stimulating. Ernst was heavy and stiff.'

Then the sitting resumes, and I turn our conversation over in my mind. Francis Bacon (1909–92) was, and perhaps always will be, bracketed with LF in the minds of historians. Great British painters, one might say, imitate the proverbial behaviour of buses. None come along for a century or more, then two at the same time. In the decades after 1800 there were J. M. W. Turner and John Constable, then none of international consequence, except perhaps Walter Sickert, until Bacon and Freud after the Second World War.

Like Turner and Constable, however, Bacon and Freud were an ill-assorted pair of artists, dissimilar in as many ways as they resembled one another. Both were figurative painters, producing images of human beings in an era when the fashions of art had turned largely to abstraction. They were friends for many years – on much closer terms than Turner and Constable. But in many ways they were opposites.

Bacon was a fast painter, sometimes actually flinging paint at the canvas to produce an effect of spume and splatter; LF is

and always has been extraordinarily slow in his pace of work. Bacon worked often from his imagination, using imagery that dropped into his mind, he said, 'like slides'. LF, as a mature artist, has never invented anything. He wants, he has said, his models to be the drama in his pictures: just them, in the studio.

Bacon seldom worked from living people, finding the distortions he wished to inflict on his subjects' appearance embarrassing in their actual presence. He preferred to use photographs as a starting point when painting a specific person. A close and prolonged encounter such as I have just begun with LF would have been unthinkable with Bacon.

...

During this first sitting, the embryonic picture has started its existence in the form of a few charcoal lines that come, by the end, to look like a face: two eyes appear, a nose, mouth, emphatic eyebrows, tousled hair. This is just the tentative beginning; the guide that, as LF explains, he does not necessarily 'go by'.

After the sitting is over, about nine o'clock, LF announces: 'I'll just change and then we'll go out to dinner.' Then we take a taxi to the Wolseley, a restaurant that has recently opened on Piccadilly. It turns out to be a huge, animated room, decorated in a sort of art deco classical style, in a wonderful building that was originally a car showroom between the wars. It is full of waiters and waitresses dashing about with orders, and a hubbub of conversation at different tables, just like the nicest sort of Parisian brasserie. LF knows one of the owners, Jeremy King, whom he introduces, then tells me King is an expert at judo, a black belt I think, and relates various exploits of his.

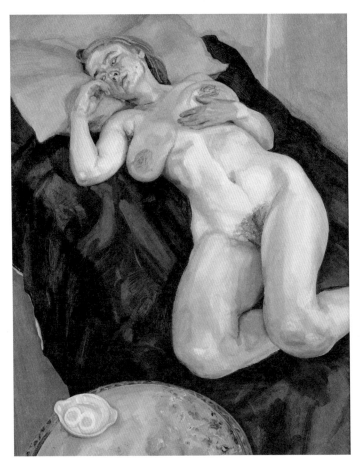

Naked Portrait with Egg, 1980–81

The meal after the sitting, like the chat before while LF revs himself up and gets ready to work, is evidently part of the procedure. 'After a sitting I like to join as far as possible in the feelings and emotions of my models. In a way, I don't want the picture to come from me, I want it to come from them.' Supper is an opportunity for further informal observation of the sitter, as well as a way of giving the process of sitting – which could become a grind – a pleasant social feeling. Posing in the evening is like being on a marathon dinner party for two.

LF eats *moules et frites* with relish from an enormous enamelled canister, and is going to come back at seven o'clock the following morning for breakfast with his friend the painter Frank Auerbach. Because I've got to catch the 11.15 p.m. train back to Cambridge, the meal ends quite early. For LF, going to bed as early as eleven is almost like turning in at six.

...

There is a complicated relationship between painting, cooking and eating. Quite often the subject matter of painting is food, or as we call it in English, 'still life'. The French term, *nature morte*, or dead life, describes it with bleaker honesty. The eatable is, generally speaking, dead matter, animal and vegetable, which if not consumed will soon decay. Living flesh is made by consuming other organisms. That is a fundamental biological process, one that is punningly recalled by LF's painting of a nude with two fried eggs (*Naked Portrait with Egg*, 1980–81; p. 16), as close a visual analogy between the human body and comestibles as exists in the whole of art.

Artists who are interested, like LF, in the physical being of people are necessarily interested in food. Francis Bacon used

to insist that we *are* meat, and – though one might disagree about whether there is more to the question – that contention is undeniably true. Moreover, painting – especially the thick and luscious variety often employed by painters who attempt to evoke the texture and weight of bodily existence – often uses techniques that verge on the culinary. Rembrandt, it has been discovered, used a liaison of oil and egg yolk to thicken those wonderful dollops of pigment that he used to recreate the bulge of a nose or the corrugations of a forehead. In other words, he was painting with a variety of mayonnaise.

A remark by Sickert comes to mind: 'The more our art is serious, the more will it tend to avoid the drawing-room and stick to the kitchen. The plastic arts are gross arts, dealing joyously with gross material facts ... while they will flourish in the scullery, or on the dunghill, they fade at a breath from the drawing-room.'

'Gross material facts' are exactly the subject of LF's pictures, very often. And though many would dispute he deals with them joyously (though I am not sure I would), he does so – I believe – with sympathy, tenderness and, certainly, intense seriousness. From this first evening, the sights and smells of restaurants are mingled in my mind with those of the studio: linseed oil and olive oil, saffron and yellow ochre.

1 December 2003

The talk is, I begin to realize, almost as much part of the sitting process as the drawing and painting. Portraiture requires observation of the subject, not just as an inert and

motionless living-statue, but also moving, speaking, reacting in all manner of moods and circumstances – some characteristic of the sitter's everyday behaviour, some more exceptional. It is precisely those movements of the eyes, mouth and the mobile topography of the face that make an image like a person, rather than a waxwork.

LF, consequently, is always observing. Indeed, engaging talker as he is, he is above all an observer of others, as his concise analysis of Ernst – Teutonic Parisian – suggests. A sure way to catch his attention is with a description of some odd, eccentric or simply distinctive behaviour by anyone, no matter whether he knows them or is ever likely to meet them. LF has something of a novelist's sensibility as well as a painter's omnivorous gaze.

He is also – in fact, it is part of his charm – a conversationalist rather than a monologist. That is, he is always ready to follow any subject that arises, and interested in what you have to say. Indeed, he is intensely interested in *you*. Obviously, this too is charming. That interest in other people is always awake in him, but is perhaps especially strong when you are the subject of a picture. We have chatted many times before, but I think I detect a heightened level of attention now that I have become raw material for a work.

It turns out to be temptingly easy to start a dialogue while LF is painting. The disadvantage is that as soon as this happens he concentrates on talking rather than painting. Therefore, the more we are diverted into conversation the more entertaining the sittings will become, but the longer the whole picture will take.

· · ·

The portrait is a variety of art that has developed in Western art over five millennia since the age of the pyramids. Its subject is the individuality of a particular person: the sitter. So, in a sense, a portrait is all about the model. But, of course, it is also an expression of the mind, sensibility and skills of its creator: the artist. A picture of a person by Rembrandt or Velázquez reveals as much – or more – about them as it does about the seventeenth-century Dutch or Spanish person who happened to be their sitter.

Then again, perhaps the true subject of a portrait is the interchange between painter and subject – what the sitter consciously or unconsciously reveals, and the artist picks up. Out of the sittings comes, with luck, a new entity: a picture that succeeds and fails – that is, lives on in human memory or disappears – according to its power as a work of art.

. . .

It follows that, like other forms of observation, portraiture is a two-way activity. In the study of linguistics, there is a complication known as the 'observer's paradox', which was formulated by a sociolinguist named William Labov. It states: 'The aim of linguistic research in the community must be to find out how people talk when they are not being systematically observed; yet we can only obtain this data by systematic observation.'

The artist at work on a portrait is in a similar position. By observing me, LF is altering my behaviour. I am, in the studio, behaving slightly differently than I do anywhere else.

For the artist it is important to elicit the facial movements, glances and expressions through which in large part

we recognize and communicate with each other. But to do so the artist must interact with the sitter. Thus conversation is not just a by-product of the portrait sittings, a way of passing the time and keeping the subject from sinking into a slough of boredom. Of course, it is that too, and especially useful for an artist such as LF whose way of working is so extravagantly demanding of the sitter's time. But it is also necessary.

In 1954, a lifetime ago when I was a toddler, LF wrote some notes on his approach for *Encounter* magazine, which still in some ways describe what he does: 'The subject must be kept under closest observation: if this is done, day and night, the subject – he, she, or it – will eventually reveal the *all* without which selection itself is not possible.'

What the much younger LF didn't add was that this observation is ineluctably an exchange. While the artist is gathering the materials necessary for the portrait, the sitter – accidentally and automatically – is provided with a similar set of observations of the artist. By the end of this picture, I shall be in possession of a mental portrait of LF, culled from all the hours of looking at and listening to him.

. . .

For LF, everything he depicts is a portrait. His peculiarity in the history of art is that he is aware of the individuality of absolutely everything. He has a completely un-Platonic sensibility, to put it in philosophical terms. In his work, nothing is generalized, idealized or generic. He insists that the most humble and – to most people – nondescript items have their own characteristics.

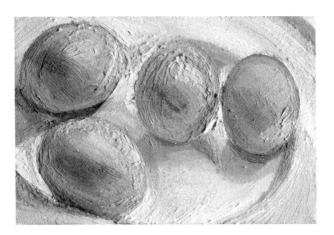

Four Eggs on a Plate, 2002

Even in the case of a manufactured item, such as a shirt, he finds that one example will be slightly unlike another, a hanging thread perhaps, a different turn of the collar. A year ago, when he was painting a still life of four eggs (p. 22), he discovered that on close examination each showed distinct personal traits. So the still life turned into a sort of group portrait. It follows that all Freud's pictures of people are portraits. He likes to call his nudes 'naked portraits'.

In his work of the late 1940s and early 1950s, this concentration on uniqueness was expressed in extraordinary levels of surface detail. His portraits of that time seem to itemize every hair on his subjects' heads. They include such minutiae of appearance as the markings in the irises of their eyes, and individual eyelashes: details of which in normal life one is scarcely aware. This attention to detail did not mean, of course, that even then he included everything he saw. That would be a mechanical and, for an artist, unproductive way to work. He was selecting, and including what seemed relevant to the picture.

The eyes and the hair, at that stage, seemed especially to fascinate him. In terms of biology and psychology, that instinct was absolutely correct. Although it is almost impossible to produce an accurate description in words of any human face beyond generalities – brown hair, big nose, thin lips – in reality each set of human features is minutely individualized. Each is unique.

The whorls, spokes and spots of the iris – so finely drawn in LF's works of over half a century ago, such as *Man at Night (Self Portrait)* (1947–48; p. 24) – differ slightly in every member of the human race. Soon we will be drawing money from cash machines and strolling through border security on the basis of those patterns in our irises.

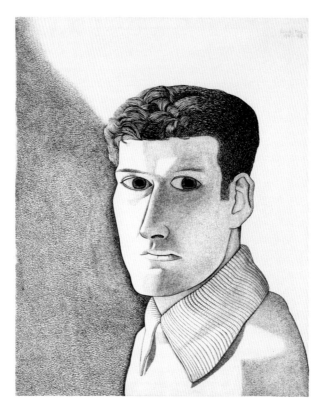

Man at Night (Self Portrait), 1947–48

In his book *The Poetics of Space* (1958), the critic and philosopher Gaston Bachelard quotes the advice of a dictionary of botany: 'Reader, study the periwinkle in detail, and you will see how detail increases an object's stature.' 'To use a magnifying glass', Bachelard comments a little later, 'is to pay attention.'

Sixty years ago, LF seemed to paint with a magnifying glass, which was a sign of the intensity of attention he was paying to his subject. Although his work has changed enormously over the years, that hasn't altered. The process we have embarked on is going to be, in part, a matter of focusing on apparently small matters: the fall of a lock of hair, the hang of a jacket.

Another way of paying attention to something is to expend time concentrating on it. There, LF is extravagant. He takes as long as the painting seems to require: always dozens of hours, sometimes hundreds. Human models differ from eggs and shirts in lots of ways, of course, one being that they are conscious of the passage of time. And sitting for LF takes up a great deal of that, although quite how much is unpredictable. He has been known to abandon work on a picture after months of effort, which may well be the end of the matter. Or, alternatively, he may perhaps start on it again once more after another long interval.

At the moment, LF is painting horses at a stables discovered by his assistant, the painter and photographer David Dawson, in a remote area of west London. One of the current paintings, he says, is of a horse's body from its shoulders back to the tail, but without its neck or head (p. 27). 'It's one of the darkest paintings I've done because the horse is piebald and the stable is very shadowy. It's a sort

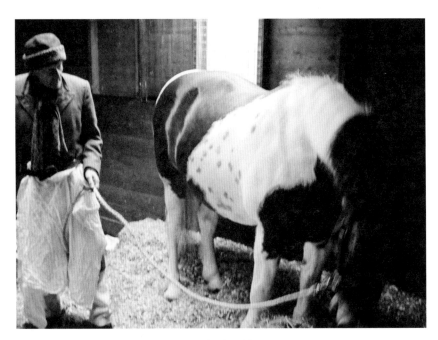

Lucian Freud at the stables, 2003

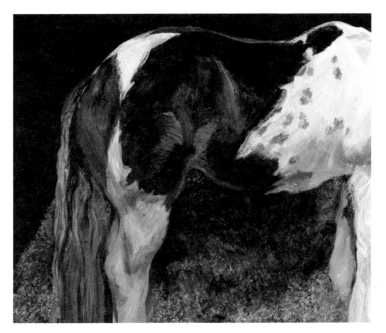

Skewbald Mare, 2004

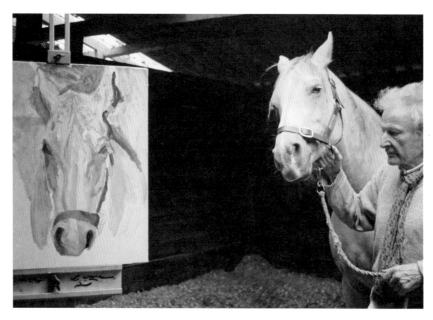

Grey Gelding (work in progress), 2003

of nude. The other, of a very old grey gelding, is a portrait.' By that, I suppose he means, the first is a picture of the animal's body, the second of its face.

The latter, the head of the grey gelding at the stables (p. 28), is just finished – and took only twenty painting sessions, 'which is amazingly fast'. LF seems to have been a little taken aback by the sudden and early completion of this picture. 'But', he says, 'suddenly, it was quite definitely finished.'

Normally, progress is much slower. A picture of Andrew Parker Bowles in dress uniform as an officer of the Household Cavalry has already been going on for a year and a month. (LF thought it had been maybe six months, but was corrected by Parker Bowles who, as the sitter, was naturally aware of just how long it had taken.) It has now reached the zone of the subject's feet and will carry on for a good time yet. The picture stands, waiting for the next session, in the other half of the studio (p. 30).

Sometimes, as time goes on, pictures expand. A big painting of David Dawson lying naked on a bed with his dog, Eli (p. 32) – which is being painted at LF's other studio in Holland Park – is currently at a workshop having an extra piece of canvas attached to make it even larger.

It remains to be seen whether this one of me is going to be a fast Freud, a slow Freud, or – a depressing thought – a Freud that is abandoned halfway through. So an incalculable interval stretches ahead before the picture is going to be finished, many months certainly. What will it be like to sit in that leather chair for hour after hour, week after week?

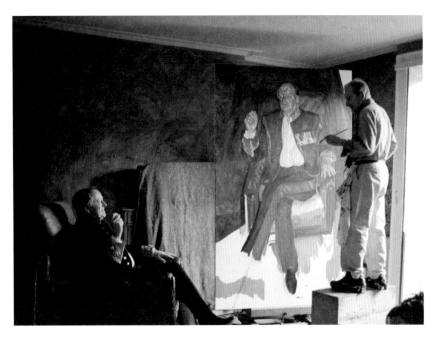

Painting Andrew Parker Bowles, 2003

W hen I arrive, LF remarks that he is feeling rough: 'Not ill, but unusually mortal; although I think that when I make all my complaints about my health, it's really because I expect to feel very well all the time.' He had already spent four hours or so on the horse's back and hindquarters in the morning, and had another long sitting with a girl who poses in the afternoon.

LF has worked standing up since a moment in Paris in the 1950s, before which he always sat down. This makes his working procedure, which may involve three sittings a day and as much as ten hours' work, quite an arduous one for a man of very nearly eighty-one (his birthday is in five days' time, on the eighth). LF makes green tea and we talk for a while, then we go upstairs to the studio and the sitting begins.

This is the first moment when paint will actually go on the canvas. There is, it emerges, a preliminary ritual when LF is using pigment. First, he rummages around and finds a palette, thickly encrusted with worms and gouts of dried pigment. Then he spends a considerable amount of time carefully cleaning a zone at the bottom left near the thumbhole. There follows more casting around for suitable brushes and tubes of paint that lie around in mounds on a portable trolley and on top of a cupboard near the wall. From the pile of old ragged sheets in the corner of the studio he selects a clean section, tears off a square and tucks it into his waistband, like a very informal butcher or baker.

These rags are another element in the arrangement of the studio. They lie around in piles in the corners of the room. In a couple of paintings of a decade and a half ago, two nudes of the same model entitled *Standing by the Rags* (1988–89) and

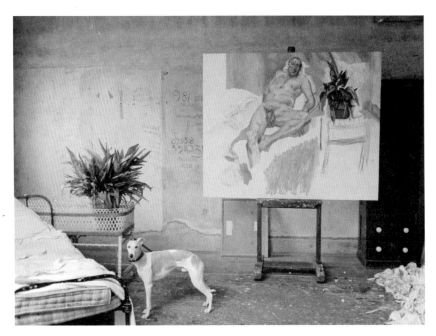

David and Eli (work in progress), 2003

Lying by the Rags (1989–90), they are an important part of the visual architecture, billowing like the clouds in a scene of saints in heaven by Titian or Veronese, but real. When LF lived in Paddington, at one point he lodged above a rag-and-bone shop, 'and I discovered the rags were of great use to me'. They've been part of his equipment, and the furnishings of his studios, ever since.

The rag-apron is used for wiping brushes and occasionally the palette knife. The larger palette scrapings are wiped on the walls, where they radiate in areas, and on the doorframe. Blobs of pigment have been trodden into the floor and telephone numbers and cryptic words scribbled on the plaster. 'Buddleia', reads one. Two tall chairs, covered in a splatter of paint, do duty as extra trolleys on which LF stores a jumble of tubes. Often he carefully, though precariously, balances his palette on the back of one of these when he leaves the room.

The effect of the paint-smeared interior is very much like certain kinds of abstract painting, or – changing the metaphor – a nest which LF has slowly, almost accidentally, constructed through the routines of his work. The walls themselves, apart from the starbursts and crusting of vigorously trowelled paint, are washed in a neutral brown.

Outside the studio, up and down the stairs, little patches and speckles of stray pigment also proliferate It is a strange effect in this otherwise perfect mid-eighteenth-century house; one that LF accepts, I presume, because it humanizes – personalizes – the spaces. 'Sometimes someone goes to the bathroom upstairs, and I quite like the way they leave traces.'

Architecturally, this studio, one of the two in which LF regularly works, is a perfect, elegant double Georgian room. It has a couple of fine original fireplaces and window frames

with shutters. In the half of the room in which I sit, the part dedicated to night pictures, those shutters are permanently closed. This adds to the studio's sense of tranquil intimacy. Outside, there is a busy street with traffic, shops, restaurants and passers-by. But behind the shutters the noise is muffled. Inside it is peaceful, secluded. There is nothing that needs to happen here except the slow progress of the picture.

Talking about work, I quote Duke Ellington's quip, 'I don't need time, I need a deadline', which more or less expresses my own experience. LF is amused, but his own attitude is the opposite. 'When one is doing something to do with quality, even a lifetime doesn't seem enough.'

Time is his luxury, and he is prepared to spend any amount that is necessary to get a picture right, which is another paradox, since by nature LF is packed with nervous energy and still apt, for example, to dive into traffic and sprint down the road in pursuit of a taxi. 'All my patience', he notes, 'has gone into my work, leaving none for my life.'

...

Artists' studios are highly specialized spaces, and they are all different from each other. A studio is, in a way, a particular kind of workshop. Like a kitchen, it is a room dedicated to doing a certain kind of job; in this case, not making food but producing art. And studios are at least as varied as kitchens, perhaps more so. Some are as neat and orderly as laboratories. Mondrian, living in a tiny apartment in Paris between the wars, transformed his working environment into a three-dimensional equivalent to his paintings. He lived amid a careful arrangement of square panels and vertical lines, interrupted by one cylindrical object: his bright red stove.

Francis Bacon, on the other hand, made his pictures in a midden of discarded items and detritus – champagne boxes, old Frank Sinatra LPs, magazines and newspapers containing possible source material for his work, abandoned canvases – all of which was excavated with archaeological care from his flat at 7 Reece Mews in Kensington after his death in 1992, and reassembled in the Hugh Lane Gallery, Dublin.

LF's studio is towards the messy, disorderly end of this scale, without being as extreme as Bacon's room. It has a characteristic quality of not being arranged, but of being – as his sitters are in his paintings – just as it is, the aristocratically beautiful lines of the architecture left exactly as he found them. A sensuous element is added by the pervading smell of oil paint. LF loves paint, even liking the smell of linseed oil when he encounters it because it reminds him of paint.

The studio is the setting for numerous works of art, many in the past, several going on at the moment. In addition to the picture of me and the full-length of Andrew Parker Bowles in uniform, there is also an etching of the girl who comes in the afternoon and a nude, almost finished, that a model sits for on evenings when I am not there. In this, the naked model is sitting up on the cast-iron bed – a piece of furniture on which many different bodies have posed for innumerable hours – her back against the pillow, with a few cherries scattered on the mattress beside her (p. 36). LF has recently added a plume of fluff escaping from the pillow that lies beneath her legs. This has the effect of enlivening the bottom of the picture. You have to be extremely careful when walking past the bed, as a jog or even an abrupt current of air might move these particles of down. The fluff, too, is posing.

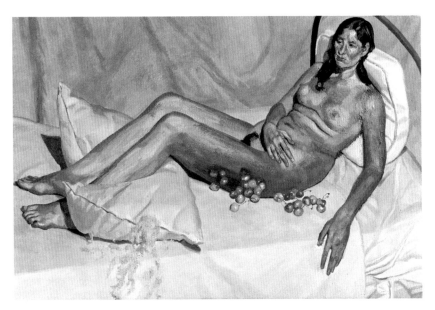

Irish Woman on a Bed, 2003–04

It would be wrong to say that LF's paintings were staged; indeed, they are the opposite: untheatrical. But, as he does with his human models, he tries to find new and different aspects of the furnishings and architecture of this almost bare room for each new work. He says that he has spent a lot of time painting floorboards, and is always attempting new ways to represent these worn and pigment-stained bits of wood.

Does he, I ask, know how he is going to carry on when he finishes a sitting?

'No, I deliberately don't – which is not so much to do with my mind as to do with not wanting to have any particular method. I don't like to plan in advance. I lean my pictures against the wall in here when I'm not working on them, and sometimes when I'm looking for one I really have to search. That's part of the process, too, in a way. When I'm working on a picture I don't want to be thinking about other pictures I'm doing. I usually have five or six going on at a given time. But when I'm working on one I just want to think it's the only picture of mine that exists – I want it in a way to be the only picture that exists at all.'

Each of the pictures has its own location, and different items of furniture feature in them. Between sittings, these chairs and beds are pushed out of the way, and the pictures themselves are placed face inwards against the wall.

The difference between a daylight picture and a night one is an iron distinction in LF's work, though not one that is always noted by critics. It is crucial for him that the light source should be constant for any given picture. For my portrait, it is a pool of electric illumination, cast by a powerful lamp hanging from the ceiling about halfway between us. These arrangements, once set up, must remain in place until

the picture is finished. They become part of one's life. And, also, one is aware of other setups for other pictures going on in the studio. Their sitters become invisible companions.

...

LF is, when one comes to think of it, essentially an indoor artist. Virtually all his human subjects are observed in the studio, even the horses are in their stable. His landscapes, almost all of them, are seen from a studio window. Indeed, when walking to my place in the chair before the easel, I can see one of his botanical subjects. Through the big eighteenth-century sash window at the back of the studio are visible the leaves and flowers of a huge buddleia bush – a tree really – that wave in the breeze outside (p. 39).

LF's taste in plants and landscape are very much like his preferences in human models. He likes them unadorned, as they actually are. His attitude to his garden exemplifies this perfectly. It has been taken over by a positive forest grove of buddleia, a wild shrub native to London that many might consider a weed but he has allowed to behave just as it wanted to. A couple of years ago it had developed into a dense, almost impenetrable, thicket, which was the subject for a couple of etchings.

The second, and so far last, of these garden etchings is about as close as LF ever comes to a work executed *en plein air* (p. 40). It was done on the veranda behind the ground floor of the house, where the copper plate stood on its easel, for month after month, flecked with bird droppings until it was almost as weathered as a rock or a tree trunk. This tangle of vegetation brought him close to the effects created by an abstract painter such as Jackson Pollock.

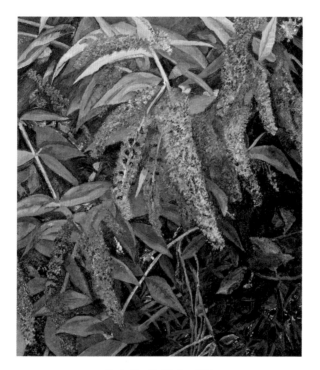

Garden from the Window, 2002

The Painter's Garden, 2003–04

LF is entirely unprejudiced about styles and media of art, but he wants a work of art to have a certain quality of reality. He admires the geometric canvases of Mondrian, which are apparently a long way from his own work. But he adds that they have – as all good things do – 'a sense of the world in them, don't you think? I am only interested in art that is in some way concerned with truth. I could not care less whether it is abstract or what form it takes.'

...

Context is crucial to portraiture. In fact, according to Malcolm Gladwell in his book *The Tipping Point* (2000), 'the Power of Context', is crucial to all varieties of human behaviour. We are, he argues, 'exquisitely sensitive' to changes in context. Thus in a dirty, graffiti-covered environment people will commit crimes that in a clean and orderly space they do not. Divide liberal-minded American psychology students into groups of warders and prisoners, place them in a prison-like building, and in a short time the former have turned into bullying martinets, the second into cringing victims.

'Character,' writes Gladwell, 'isn't what we think it is or, rather, what we want it to be. It isn't a stable, easily identifiable set of closely related traits ... Character is more like a bundle of habits and tendencies and interests, loosely bound together and dependent, at certain times, on circumstances and context. The reason that most of us seem to have a consistent character is that most of us are really good at controlling our environment.'

But put us in a filthy, broken-down subway and we may behave differently from the way we would at a dinner party. Or, one might add, in an artist's studio.

LF's studio is a most unusual place to be. Perhaps, in that odd space, and during that long, long period of time, people become, as David Dawson says, 'most themselves', even if that means slumping in boredom and weariness, or wandering off into an inner maze of thoughts and associations.

Or, possibly, as the philosopher Derek Parfit argued in articles I wrote essays about long ago as an undergraduate, there is really no such thing as a persisting individual identity. All that truly exists in our brains is connectedness – memories, character traits that persist through time, but more in some cases than others.

In my case, that spool of memory runs back to a day when I was two, and parked in my pushchair outside the local grocer's shop, when unexpectedly my father arrived in our car, causing such surprise and happiness that this trivial event was permanently engraved on the hard disk of my mind. LF's own memory-chain extends back into the Weimar Republic Germany of the 1920s, when he swapped cigarette cards in Potsdamer Platz and went on seaside holidays to the little island of Hiddensee, off Rügen in the Baltic.

Am I the same individual who penned those thoughts on Parfit and his theories, decades ago? Well, in some respects yes – but certainly not entirely. What, then, is a portrait painter painting? An individual who persists though time, or merely the way a ceaselessly mutating human organism appears in a particular time and place? It is a good question.

...

At first I thought of sitting as being similar to a visit to the hairdresser's, but now it seems more intense. The experience

is like no other in that the sitter – that is, me – has become a mystery: a puzzle to be solved.

LF leans forward sometimes, shading his eyes like a sailor in search of land. His demeanour when painting is that of an explorer or hunter in some dark forest. He peers at me, holding his palette in his hand, with the brushes he is not using held between his little finger and the next, protruding like arrows in a quiver. His attitude is a combination of audacity with caution: an intense determination to get the thing exactly right.

Often before making a stroke LF expels air in a little sigh with the effort of concentration. The same attention is applied to the mixing of colours: 'I think just a little', 'No, that's not it.' He will often sigh again and give a little gesture between a shrug and a triumphant wave of the arms after a successful application of the brush, as though while building a house of cards he has just successfully placed a particularly tricky one. When he is really concentrating he mutters constantly, giving himself instructions: 'Yes, perhaps – a bit', 'Quite!', 'No-o, I don't think so', 'A bit more yellow.' Once or twice he is about to apply a stroke, then withdraws, considers again, then re-scrutinizes, measuring my face with little mapping movements of the brush, describing a small curve in the air or moving it upwards. The whole procedure is hugely deliberative.

When I get up and stretch my legs after about forty minutes of work, despite what seemed to be plenty of vigorous activity with the brush, little seems to have changed on the canvas. By the end of the evening two eyebrows have appeared, and a little flesh around the bridge of my nose.

. . .

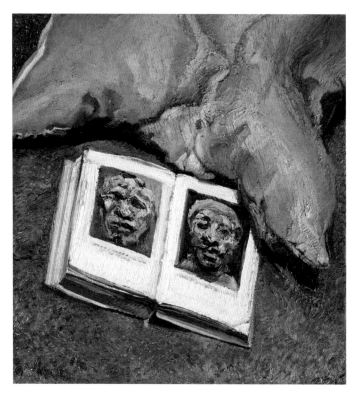

Still Life with Book, 1993

In 1939, when he was sixteen, LF was given a picture book called *Geschichte Aegyptens* (History of Egypt). He has been looking at it ever since, and especially at a double-page spread showing photographs of two of the plaster portrait heads excavated in the ruins of the workshop of the court sculptor Thutmose at Amarna in Middle Egypt. At the beginning of the 1990s, LF made two paintings and an etching of this book, open at those pages, showing the faces of people who lived in the fourteenth century BC (p. 44). Those ancient portraits mean a great deal to him. They are, you might say, representations of pure being. Beyond the fact that they were ancient Egyptians, living at the court of the heretic pharaoh Akhenaten, it is impossible to be sure of anything about them. But that doesn't affect their ability to move and fascinate, 3,000 years after they were made.

This brings out a wider point about portraits. Sometimes we are interested in them because of whom they depict – our grandfather, or Henry VIII. Very often, however, we neither know nor care. It has minimal effect on our reaction to the *Mona Lisa* that it is very probably a picture of a Florentine woman named Lisa Gherardini, because we know so little about her. The appeal of the picture lies entirely in how it looks (or it doesn't, if you agree with LF and think that 'someone should write a book about what a bad painter Leonardo da Vinci was').

It is, if you think about it, a remarkable fact that we can be so impressed and involved by representations of people long dead, of whose names and lives we know nothing. The reason, perhaps, is that we see in their features what we know about people: friends, family, acquaintances. When the diggers working for an early Egyptologist, Auguste Mariette,

revealed a wooden statue from the Fifth Dynasty (a thousand years earlier still than the faces in LF's book) they exclaimed 'Sheikh el-Belad' – the Arabic title for the chief of the village – because it looked so like the leader of their own community (p.47). A twenty-first century viewer might note it looks quite like Leigh Bowery, LF's favourite model of the early 1990s.

We respond to a *Portrait of a Man* by Jan van Eyck or Titian in ignorance of the sitter's personality just as we do to those Egyptian plaster faces – or many of LF's own works. Sometimes, especially when painting fellow artists, such as David Hockney, he gives his portraits the names of their sitters. Much more frequently, he does not. *Red Haired Man on a Chair* (1962–63), *Woman in a White Shirt* (1956–57): those are much more typical. It is a way of emphasizing that the personal details of the sitter – that the *Woman in a White Shirt* is the Duchess of Devonshire, for example – don't much matter. What is important is the result of his observation and concentration: the picture.

That will fulfil, perhaps, the ambition Van Gogh confessed to his sister Wilhelmina in a letter written on 5 June 1890, the month before he killed himself. 'What I'm most passionate about, much much more than all the rest in my profession – is the portrait, the modern portrait ... I WOULD LIKE, you see I'm far from saying that I can do all this, but anyway I'm aiming at it, I *would like* to do portraits which would look like apparitions to people a century later. So I don't try to do us by photographic resemblance, but by our passionate expressions.'

...

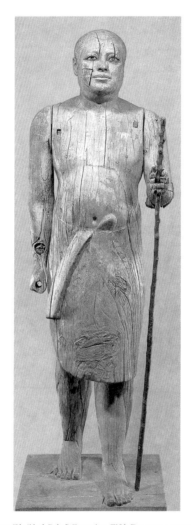

Ka-aper (Sheikh el-Belad), Egyptian, Fifth Dynasty, *c.* 2475–67 BC

The ancient Egyptians created the earliest great portraits to have survived. Perhaps that was the reason why Francis Bacon finally decided that they were the greatest artists of all. But there are thought-provoking features about carvings such as the Sheikh el-Belad. One is that they were not intended for anyone to see, but were sealed up in the tomb of the subject. They were, in many cases, intended as substitutes, 'alternate abodes for the spirit – the *ka* – of the deceased'. The disturbing notion of the portrait as an alter ego, a hidden twin – the Dorian Gray theme – seems to go back right to the beginning of portraiture.

The other point is that though they could achieve likeness – or certainly, the vivid impression of an individual face – the Egyptians do not seem to have cared that much about it. The care-worn, deeply thoughtful carvings of Middle Kingdom pharaohs seem the most wonderful representations of specific individuals. Perhaps, however, they aren't real portraits at all – they look oddly like one another when you put them side by side – but images of the weariness of kingship. But then, perhaps when we contemplate one of these sculptures we are not really looking at the Pharaoh Sesostris or Senusret but, as LF put it, at humanity.

Nearly half a century ago, in his 1954 *Encounter* article, LF wrote some words that suggest an exact likeness is not and cannot be the point of portraiture. 'The artist who tries to serve nature is only an executive artist. And, since the model he so faithfully copies is not going to be hung up next to the picture, since the picture is going to be there on its own, it is of no interest whether it is an accurate copy of the model.'

It is a cold clear day. LF claims not to have slept last night or only half-drowsed. At four o'clock in the morning he got up and thought of doing some painting – but for once didn't feel like it and went back to bed. If he works early like this, he has 'the feeling when people start going past on the way to work at seven, that I've already accomplished something'.

Later he got very cold in the stables. But as he paints he seems to inflate and shed years. LF says, 'This is the first time I've felt really well all day.' He is wearing, instead of his usual paint-streaked boots, a new pair of trainers with what look like large springs between soles and uppers. These help him with standing for so many hours. In fact, he is not so much standing as constantly dancing around – stepping back to consider an effect, leaning forward to inspect me more closely, prowling around the studio to locate a tube of Naples Yellow or Burnt Umber.

This time he is attacking my forehead. When we have an intermission, I begin to see how the structure is starting to emerge, with two large clip-like shadows on either side, and various sections in different pinks and beiges cropping up in between.

This patch of face might seem an arbitrary point at which to start. On reflection, however, perhaps it is not. Asked to point at 'me' in their face, many people indicate a spot above the bridge of their nose. Behind the forehead, physiologically, lies the frontal cortex, a section of the brain that controls emotion and is important in forming judgments.

It is not, then, a bad place to begin, granted that LF's method requires him to set down a definite set of marks somewhere on the canvas. His way of working is highly

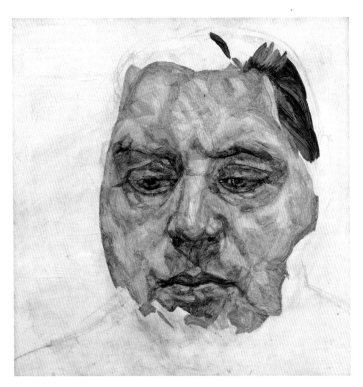

Francis Bacon, 1956–57

idiosyncratic. Other painters have described it to me as 'completely crazy'. Many artists, when embarking on a picture such as this portrait would first make a loose, all-over sketch, which they would then elaborate, refine and sharpen until the whole is finished.

LF, on the other hand, as he has with this painting, is inclined to put a blob in the middle then slowly work out from it, creating a mosaic pattern of pigment that spreads across the canvas. Though he may later adjust these first thoughts, the sections he paints look fairly 'finished' from early on, surrounded by blank white canvas. It is a process that can be seen in an incomplete painting, such as the portrait of Francis Bacon which he left off when the sitter departed for Morocco – or some such destination – in 1957, and never took up again (p. 50).

...

On the stairs going up to the studio I mention Emile Zola whom I am reading because Van Gogh was a passionate admirer of his novels. LF, it turns out, is not a fan. 'It's not that he is bad exactly, but his work is so full of false feeling. All the feeling is false.'

'False feeling' is exactly what LF does not like in art, or in life. What he says about the author of *Germinal* is similar to what he has to say about colours, while discussing why he doesn't like taking drugs. 'People say such things as, "Oh, they make me see such marvellous colours" – which to my mind is a horrible idea. I don't want to see marvellous colours. I want to see the *same* colours, and that is hard enough. Then they say that they are taken out of this world, but I don't want to be out of this world, I want to be absolutely in it, all of the time.'

LF finds Zola painful because his characters, their actions and the way they are described constantly strike him as untrue.

LF is a great reader, of newspapers – stacks of them are always lying around downstairs: the *Evening Standard, The Times, Guardian*, the *Telegraph*, the *Daily Mail* – and of poetry and novels. If he doesn't like something, his criticism of it can be annihilating. Of one celebrated living author, LF observed: 'He has that deadly thing, the popular touch' – a wonderfully disdainful judgment from an artist who was content to wait for decades for public taste to come round to his own work.

LF enjoys being critical, an activity that, characteristically, he thinks of in terms of its psychological and physiological effects: 'It's exhilarating.' Discussing visual artists he dislikes, LF is if anything even more scathing. On Dante Gabriel Rossetti: 'He's the worst of the Pre-Raphaelites, his work seems to me the nearest painting can get to bad breath.'

On the other hand, there are books and writers to which he often returns in conversation, for which his enthusiasm is vast and unreserved, as he argues it should be for people you really like, or love, extending even to their faults. Henry James is a favourite novelist, as are Gustave Flaubert and Thomas Hardy. Of the last, he says, 'I like him so much I even read his boring novels, because they seem boring in the way real life is boring. I've even read ones such as *The Trumpet Major* that probably almost no one has read.'

During his long life, LF has been on friendly terms with a number of writers, including, when he was young in the 1940s, W. H. Auden and George Orwell. 'I knew Orwell quite well towards the end of his life, having met him when I was working for *Horizon* magazine – where I was putting stamps on envelopes, that kind of thing. I remember visiting him in hospital near the

end, and he confessed that when he was in pain he cheered himself up by imagining similar or worse things happening to people he disliked. He thought that it was a terrible thing to think, although I should imagine everyone thinks like that from time to time.'

'I used to read Orwell's columns in *Tribune*, a magazine much read at the time. Some of the novels are good. For me, *1984* is unreadable, but *Coming Up for Air* is a bit good. I used to meet him in the Café Royal, and though some of his opinions seemed extreme, what I liked about him was that he always had reasons for them. But he was an extremely unaesthetic person. When you said that such and such was a beautiful work of art he seemed quite put out. He would say, "What do you mean? Prove it!"'

'Orwell was right about many things – the awfulness of Stalin for example, which still irritates some people. He was a very conscientious journalist, indeed I would say that he carried decency to the point of real imagination.' This is a typical thought. LF relishes the notion of a mundane quality such as decency being so accentuated that it gives its possessor a special insight. Imagination is a quality LF values highly, like liveliness – to which it is probably linked in his mind. A great deal of what is normally thought of as intelligence, he points out, is actually imagination – that is, an ability to see things as they truly are.

16 December 2003

We resume, after an interval in which I have flown to the southwest of the United States and back. At present, LF tells me, he is writing a revision of his 1954 piece

on painting at the instigation of Geordie Greig, editor of the *Tatler*, who asked if he could reprint the original. 'I said, "of course", but I went on to say that I completely disagreed with much of it all these years later. So he asked me to write another piece explaining what I think now.'

And how has his thinking changed over the last forty-nine years? 'Now I know that the main point about painting is paint: that it is all about paint. To date, I've written three new sentences. I thought of another one today, in a taxi. Writing is so enormously hard that I can't understand how anyone can be a writer.'

. . .

More conversation follows, before we climb upstairs to the studio, about Raphael's *Madonna of the Pinks* (*c.* 1506–07), which the National Gallery in London is attempting to buy. Raphael, smoothly elegant master of the High Renaissance, is a painter in whose work LF has no interest at all. Looking at them, he says, 'I sometimes can't tell what way up they are supposed to be', which is his way of saying that Raphael's figures are completely without the sense of weight and physical particularity that he values.

He is even tempted to agree with those who suspect that the *Madonna of the Pinks* isn't really authentic – but for a very backhanded reason: 'Normally I can't bear Raphael, but I liked that one a little bit.' In fact, looking at it with that in mind, one can see in its tenderness, intimacy and freshness a glimmer of a Freudian feel.

I think that the *Madonna* must be right, as they say in the art world – that is, genuine. So, what this really means is that LF only appreciates Raphael when he's un-Raphaelesque.

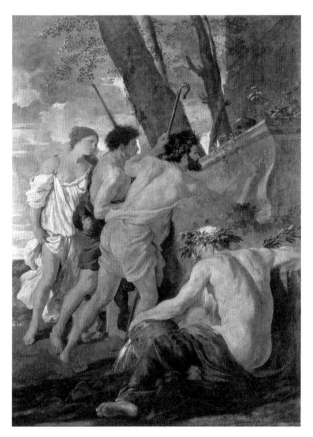

Nicolas Poussin, *Et in Arcadia Ego*, 1628

Similarly, he occasionally admires Nicolas Poussin – but only when he was least like Raphael and most like Titian.

'There's a very good one at Chatsworth,' he says of Poussin. 'It's one of the ones that don't rhyme.' The picture in question, *Et in Arcadia Ego* or *The Arcadian Shepherds* (1628; p. 55) is indeed calculated to appeal to LF. In the foreground, a river god snoozes, his back at once powerful and flabby like the back of Leigh Bowery in his own *Naked Man, Back View* (1991–92; p. 57). Behind, three figures – a delicately painted young woman, a nymph and a bearded man – confront a tomb on which they are in the process of reading the words 'Et in Arcadia Ego' ('I too lived in Arcadia'). It is a picture about a confrontation with the fact of death.

What LF means by pictures 'rhyming' is a graceful flow of forms, each interlocking or echoing another. 'I think that somehow, if all the forms fit together smoothly and neatly, the painting is never really memorable. For that reason I think of Poussin as an Italian painter not a French one. I really love French painting, not Italian. In that sense, I suppose Titian isn't an Italian painter either.'

It's a bit whimsically expressed, but one sees what he means. In LF's shorthand, 'Italian' equals Raphaelesque. 'French' means having a sense of unhomogenized reality. That's what he is after in his work: a feeling of the weight, texture and irreducible uniqueness of what he sees. Rightly and inevitably artists see all other art in relation to their own. That's why another non-favourite of his is Johannes Vermeer.

The people in Vermeer's painting, he explains, aren't substantial. 'It isn't', he goes on, 'a matter of incompetence. It is that in a funny way his people just aren't there.' He far prefers Chardin, in whose work, for all its eighteenth-century

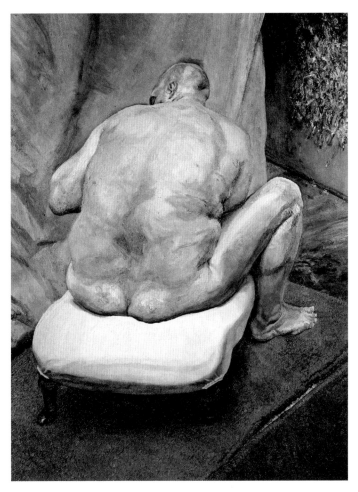

Naked Man, Back View, 1991–92

poise, the creamy paint actually seems to turn into the surface of the figures' skin. You feel you could put your arm round his *Young Schoolmistress* (p. 186) in the National Gallery in London.

In 1995 I suggested in a column in the *Spectator* magazine that Francis Bacon's famous phrase, 'the brutality of fact', applied also to LF's work. The critic David Sylvester, friend and interviewer of Bacon, immediately contradicted this in a piece he wrote for another newspaper.

'Bacon hit upon that phrase when trying to define a key quality which he found in Picasso but found wanting in Matisse, a quality that clearly involves a sense of the human condition, which in turn demands a measure of universality. Freud seems to see the world at close range through his own eyes only, painting attractive or repulsive sights according to his personal whim.'

There, Sylvester, it seems to me, did something that critics quite often do: in attacking something he put his finger on precisely its unique and marvellous positive quality. It is exactly LF's treatment of the world as made up entirely of unique individual things – people, animals, objects – that is his greatest strength. He has resisted the tendency of modernist art to subdue the complexity of the world to a style or a concept. But maybe 'the brutality of fact' isn't a phrase that precisely suits what he does. Perhaps, 'the awkwardness of truth' would be nearer the mark.

. . .

Although his art has nothing to do with narrative or telling stories, LF has a novelist's attitude to people; he has a voracious appetite for different varieties of behaviour and character, so long as they strike him as authentic rather than

false, affected or otherwise dreary. He once referred to his 'Harun al-Rashid side'. Just as the caliph was said to slip out of his palace to pass unnoticed among the people of Baghdad, LF has ventured into many diverse strata and byways of London life, including, at one stage, an underworld that would have intrigued Honoré de Balzac or Charles Dickens.

During a break, he mentions that he happened once to discover that he was on file with the police as 'an associate of criminals', 'which oddly enough was exactly what I was. I did too much of it really. They would give me a suitcase and say, "Look after this, Lu" and I'd look inside and it would be full of money.'

'They were my neighbours in Paddington. After I stopped working on the merchant boat in 1942 and decided to live in London and paint, I found an enormous house there which was very cheap – only £80 a year, or something like that. My father said that soon the war would be over and then there'd be a housing shortage, and I wouldn't be very popular for rattling around in this huge place. So in the end I took only one floor – two big rooms. My neighbours thought it was large as it was: "What do you do with all that space, Lu?" They'd have had five or six people living in a flat like that.'

'They were marvellous neighbours. It was an entirely working-class area. But in those days, if you were middle class, you only met working-class people in some sort of menial position, servants or working in shops, that kind of thing. But none of these people did anything like that. They only worked for themselves.'

Two of his friends of that time were the Lumley brothers, whom LF first met while they were in the act of breaking into his studio. Stephen Spender met LF and Charlie Lumley, the sitter for *Boy Smoking* (1950-51; p. 60), in a smart eating

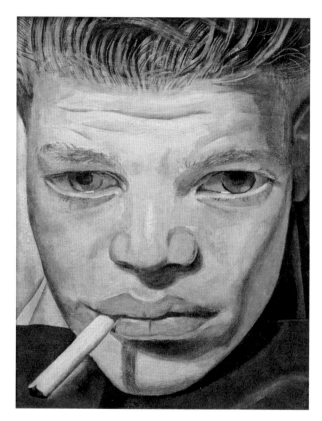

Boy Smoking, 1950–51

place in 1955. 'They were both dressed like workmen, Charlie almost in rags,' Spender recalled. 'The restaurant was appropriately shocked.'

'Quite a few of my friends and neighbours were criminals,' LF continues, 'but there was only one really clever and successful bank robber, and his friends. They would say to me, "We used to have everything – nice house, nice girlfriend, plenty of money. The only thing we didn't have was straight friends, but now we've got you."'

'They would, for example, plan to rob a certain branch of the Midland Bank, and they'd say, "Have any girlfriends or women you know got anything in the safe-deposit boxes? Because we wouldn't want to take anything from any friends of yours. You should warn them." In fact, I did mention it to one or two people, but it wasn't a success. I'd say, "Have you got anything in a safe-deposit box in such and such a bank?" "No, why do you ask?" "No reason."'

'They'd do things such as dope dogs at the racetrack, which is very easy to do. They wanted to dope one dog, but they couldn't get into the enclosure where it was because the locks were too old. So they went into the dog owner's butcher's shop, bought a huge amount of meat and left "accidentally", leaving a bag containing brand-new padlocks. Next time they went to the track, those were on the enclosure – and that was that. I thought that was really clever and imaginative.' (LF has a way of rolling the initial 'r' and emphasizing the word 'really' which is very characteristic and, like his voice and speech patterns altogether, inimitable.)

All his observations of the milieu in which he found himself naturally led to certain pictures. For instance: 'I painted the very clever bank robber a couple of times, the one who warned me he

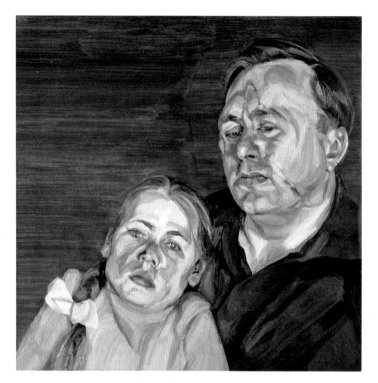

A Man and His Daughter, 1963–64

was going to rob a certain bank on a certain day. He lived under me in Clarendon Terrace. Eventually, he became a car dealer, also very successfully.' The man's face is seamed with livid scars, which contrast with his thoughtful expression and, in one picture, tender embrace of his small daughter (p. 62). 'I think the husband or boyfriend of a girl he was going with did that to him. They used to have a trick of putting a razor in a potato, and then [LF mimes a crisscross over someone's face]. That happened to some of Ronnie Kray's unfaithful boyfriends.'

'I stayed in that first house for years and then I moved to another house in the same street, then to another nearby. Eventually, they were bought up by the council, which kept warning me that I was not a unit – a unit being a family with young children, or an old retired person. So I was put in buildings that were scheduled to be demolished, which suited me fine. I remember that once I was the last person left living in a long street, and the demolition men got closer and closer. I was working on a painting in the studio. In the end I passed down some whisky bottles and they agreed to let me have another couple of days. It seemed important at the time.'

'Middle-class people did not go into this neighbourhood, as in the nineteenth century, though my mother left parcels of food on the doorstep as she was concerned about me. It reminded me of Doré's London very much. Because of not having a telephone, I'd get a lot of telegrams in those days, inviting me to parties and so forth. My neighbours would always look very gloomy and say, "A telegram, Lu?", because for them a telegram always meant bad news.'

. . .

Halfway through the sitting, my left eye appears and then by the end my right one does too. The rest of the canvas is still mainly covered by the initial charcoal drawing, except for my forehead, which is a patchwork of strokes stretching down to the bridge of my nose. Still, suddenly a person is looking out from the picture.

The look or – as it becomes with added fixity and intensity – the stare is the most primitive and powerful part of any portrait. The eyes are the source of presence and power. They contain the force in the image of a god or saint, in the icons of the Orthodox Church for example. That is why so often those who do not wish to feel that force scratch out the eyes, leaving the rest of the picture intact.

The eyes, furthermore, in their subtle movements, the way they do or don't meet our own gaze, the dilation of the pupils, are among the best clues we human beings have to each other's feelings. The pupils dilate if we look at something that interests or alarms us: men's when shown a shark or a naked woman, women's at the sight of a baby or a naked man. The eyes, through flickering and subtle movements, can express a range of emotions such as sadness and happiness, attention and inattention, desire and hate, trust and distrust, alertness and fatigue, falseness and sincerity, anger and forgiveness. Altogether it is not surprising that, with the appearance of the eyes – my eyes? – on the canvas, comes an impression that there are now three of us in the studio.

Cautiously, at the end of the sitting, I edge towards the question of how LF feels the picture is going. Presumably, I hazard, it's hard for him to estimate progress at this stage. It turns out caution was the right mode in which to broach this subject.

LF explains that, for him, each painting is an exploration into unknown territory. He quotes Pablo Picasso: 'that marvellously arrogant thing that he said to a woman who asked about a painting he was working on. "Don't speak to the driver" – which is a notice you saw then on French trams and buses. I suppose that if you had another temperament you might say: "The driver doesn't know where he's going." Personally, I can only regard any enquiry about how a picture is coming on as a particularly irritating sort of humorous remark.'

...

Constantly, in the way that a blackbird looks out for crumbs and worms, LF is on the look out for models; for people, that is, who would make suitable material for his pictures. The qualifications are hard for him to state. 'I choose the subjects of my paintings on impulse. Because I'm not very introspective it's hard for me to say just why that is.' Sometimes he depicts people he knows well, but he has known some friends very well for many years without getting round to painting them. Experience of working with other artists is a positive disadvantage.

'Professional models are likely to be unsuitable because I want it to be, "My God, you haven't got your clothes on!" not "Would you like pose A, B or C?"' There is a certain incalculable amount of potential in any given person he begins to paint.

Of one woman, who was the subject of a series of works about fifteen years ago, he recalls: 'At first she was a very bad model, which I never mind, because in a way the last thing I want to do is paint a model. Then I felt I just couldn't work from her any more. It was as if I'd worn her out in my work. I still know her, we're on perfectly good terms. That wasn't the reason.'

Occasionally, just meeting a person casually is sufficient to suggest they might make a good subject. Over dinner after the sitting, LF points out a waitress. She is tall, a bit ungainly, but singular looking. 'I've several times thought that she would be good to paint a naked portrait of. The idea has come back to me more than once.'

'Have you mentioned it to her?'

'Oh, no.'

At present, he has a full schedule comprising the horses, me, the afternoon girl, Andrew Parker Bowles and the nude with the cherries. But the odd, interesting-looking waitress is evidently at the back of his mind, just possibly a future picture, though she as yet has no suspicion of this scheme. Exactly what he sees in her, probably even he would find it hard to put into words.

19 December 2003

L F has been painting at the stables again and got very cold. 'I quite like the slight heroics of painting there almost in the open air, but this has become a bit much. I hate feeling so rough.'

Because of his current artistic interest in a horse's hind quarters, I've brought a reproduction of Caravaggio's *Conversion of St Paul* (1600–01; p. 67) – one of the more notable depictions of an equine rear end in the history of art – which he has never seen before in colour and thinks 'absolutely marvellous'. He particularly likes the jumble of human and animal limbs in the centre. This seventeenth-century horse, he says, is very close to what he is doing in angle and pose. Today he has been painting its right rear flank.

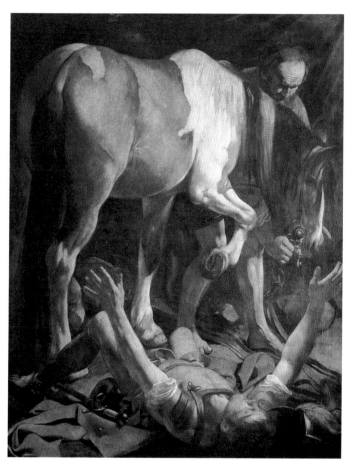

Caravaggio, *Conversion of St Paul*, 1600–01

Caravaggio's companion picture, of the *Crucifixion of St Peter*, he thinks is not so good. 'Looking at it, you get the feeling that "This is a composition", which with the other you don't.' LF dislikes art that looks too much like art, and paintings that are too smoothly put together. The awkwardness that critics sometimes complain of in LF's work is deliberate.

It was through horses, it turns out, that he first met Andrew Parker Bowles, whose portrait is now slowly creeping towards completion in the other half of the studio. About twenty years ago, LF wanted to paint a horse in the stables of the Horse Guards. Parker Bowles was then an officer in that regiment (later he commanded the Household Cavalry).

'There was one horse in the stables that had such a bad temperament that I wasn't allowed anywhere near it. It was more or less kept behind bars. I thought that was rather extreme, but they said it would be unwise even to approach it. It had bitten a trooper's ball off by twisting its head round very quickly and agilely. They kept it, though, because it was such a magnificent mount. Bad temperament in horses, if you give them continued kindness and good treatment, becomes no more than a sort of nervous tick.'

It sounds as if, characteristically, LF was a little wistful at not being allowed to draw this dangerous beast. His feeling for horses goes far back into childhood. At Dartington School in the 1930s he would sleep in the stables with the animals. 'I used to love to do that and rode a great deal.' From that period of his life there is a linocut of a runaway horse, dated 1936, when LF was thirteen, and from the following year a sculpture – a true rarity in his œuvre – of a horse with three legs.

LF has a conception of life that embraces the human and the animal as two aspects of the same thing. 'When I'm painting

people in clothes I'm always thinking very much of naked people, or animals dressed.' Some of his most memorable pictures are of people and animals – generally their owners – together: *Girl with a White Dog* (1950–51); *Guy and Speck* (1980–81). In *Double Portrait* (1985–86; p. 70) paws and hands, whippet legs and fore-arms, doggy and female noses are juxtaposed in an intimate mesh, giving a powerful sense of shared existence.

...

In the course of the sitting LF sometimes puts his hand across his forehead in concentration and dismay, once transferring a jagged lightning strike of paint from his hand to his face. Often, he holds his own head with one hand to indicate the exact angle of tilt. It is an odd sensation, his giving a perform-ance of being me. I concentrate on being alert, looking back at LF, feeling in this way I am taking part in the picture, perhaps inserting into it that alert look.

The tension of working can make LF seem very agitated at times. He gestures; he raises his arms in a movement half-triumphant, half-despairing, like an Italian taxi driver encountering a perplexing configuration of traffic. He mutters to himself. His bouts of concentration are apt to begin with an especially hard stare, followed by a deep sigh. He steps forward and back, and on occasion darts forward and springs away from the canvas, bringing his mouth down in a one-sided grimace. Sometimes he touches the picture with a brush like a person making contact with something intensely hot, or charged with electricity. The paint continues to spread across the canvas in tiny, incremental stages.

...

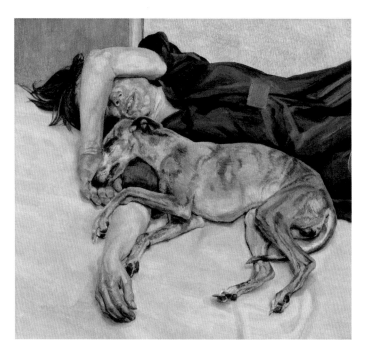

Double Portrait, 1985–86

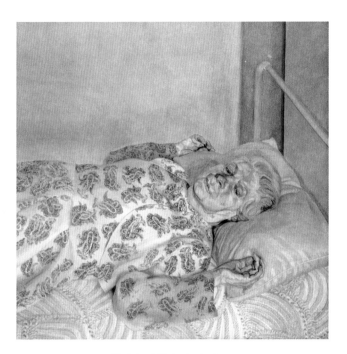

The Painter's Mother Resting, I, 1976

During a pause, I ask what the difficulties are, from his point of view, of painting a picture. His answer is unexpected.

'One thing I have never got used to, is not feeling the same from one day to the next, although I try to control it as much as possible by working absolutely all the time. I just feel so different every day that it is a wonder that any of my pictures ever work out at all.'

'When I was painting a picture of my mother years ago, I was feeling sadder than I ever have before or since. I was painting the paisley patterns on her dress and I remember worrying that my sadness would get into the paisley shapes and I suppose perhaps it did (p. 71). But I am just giving you an indication of my megalomania.'

I say: 'I suppose that one actually is different from day to day. There would be different chemicals in your bloodstream and your cells would be slightly changed.'

LF responds: 'And you will have been with different people and may wake up in a different bed, perhaps with a new person. All these kinds of things can affect you.'

The paradox of portraiture, especially this marathon variety, is that the target is always a moving one. Physiologically, and psychologically, a living being is always in a state of flux. Moods shift, energy levels go up and down, the body itself slowly ages. Since the sittings began I have been to Texas, walked in the desert and returned with a slight tan and a buoyant mood.

Outside the studio seasons slowly pass; temperatures and light levels alter. Soon it will be Christmas. As with any creative project – writing a book, for example, is the same – success is partly a matter of stamina, and also what LF likes to call 'morale': the confidence required simply to keep going. Of course, in the case of a painting such as this one, these

alterations are multiplied because two individuals are involved: painter and subject. It turns out that, from LF's point of view, it is the potential of shifting moods to affect his creative verve that bothers him most.

'What', I ask, 'is the disadvantage of being changeable for a painter?'

There is a long pause, and a sigh of concentration as when he is trying to get a brush stroke exactly right. Then: 'Perhaps when you have the sort of temperament that is always looking for flaws and trouble [his temperament, in other words], it might stop you from having what you always want, which is to be as audacious as possible. One has to find the courage to keep on trying.'

'How?'

'Not painting in a stale or predictable way. But I suppose if one didn't vary from day to day one could not be what one always wants to be – *exceptionally* daring.' So there's another paradox.

28 December 2003

There is a slight pause in the sittings over Christmas, on my part not LF's, since he tends to work right through all such festivities and never takes a holiday. 'I shouldn't want to look forward to anything that wasn't work, it would be too destabilizing.' He did, however, attend a Christmas service arranged by a nun he knows. 'I wonder how many atheist Jews there are here,' he remarked, describing himself; she replied not unreasonably, 'Oh, come on!' LF does not feel, he says, that

his Jewishness is a particularly prominent part of his sense of self. It is, however, a subject that intrigues him, especially when it is refracted through the mind of one of his sitters.

'Anti-Semitism is not something I have often experienced, and is what I would previously have thought the most boring subject imaginable. But when Isaiah Berlin was sitting to me he talked about it in such a way that I found it enormously interesting. He told me a story about two Jews in New York talking and saying what a marvellous place America was, what a sense of liberty and freedom from prejudice, and so forth. Then one says, "But I'm still afraid of dogs." The point is that, as my father once told me, in the old days in Europe it was quite common for dogs to be set on Jews.'

The painting is progressing immensely gradually down the canvas. It seems, from muttered comments – at one point an exultant, 'Yes, I think that's it, very much so, good!' – that it is going well this evening.

I ask whether it is about time for the nose to appear. Not quite yet is the answer. 'I want it to grow organically, so I wouldn't want to do the nose without having first done the section above and to either side.'

At the end of the sitting Josephine, my wife, arrives. She inspects the two eyes and accompanying eyebrows that are now to be seen on the canvas, and says she would recognize them anywhere. My eyebrows, in fact, are distinctive. They are the feature that, if I were a politician, cartoonists would concentrate on. Eyebrows are useful for signalling expressions. Charles Darwin noted that they are crucial in the facial expression of admiration. The brows rise, the mouth smiles, 'the eyes become bright, instead of remaining blank, as under simple astonishment'.

My eyebrows are thick, black and almost meet in the middle over my nose, where there is a tuft of hair. Quite what they are indicating in the painting is anyone's guess. Even LF in all probability has not yet decided: but they are definitely mine.

After this very private view of the only-just-started painting, LF opens a bottle of champagne and we sit in his sitting room upstairs above the studio, then have dinner at the Wolseley – all three choosing the same things: caviar and Irish stew, the former on LF's suggestion: 'Very good, I recommend.' It's a surprisingly successful combination.

LF takes food seriously, and cooks a bit himself, mainly out of Elizabeth David's books. I arrived once to discover the house perfumed with *cèpes à la bordelaise*. He knew Elizabeth David – and, slightly amazingly, her mother – and admires her attitude. 'She had such wonderful fastidiousness and a sense that in the end you are eating for your life. I like her distinction that her recipes, cooked in England, are not French food, but cooking *à la française*. That's exactly correct.'

Those two considerations, that what you are doing you are doing for your life, and should do fastidiously, apply to quite a few matters, in LF's opinion, and especially, of course, to painting. Fastidiousness is a trait he rates highly. 'It's such a marvellous quality, don't you agree? Not, of course, when it's a judge carefully summing up against you, but being reasonable to the point where it turns into imagination. I think that's wonderful.'

LF's taste in food is very similar to Elizabeth David's: a preference for cooking simple fresh ingredients, everything to be straightforward but just right. It was a way of eating that had somehow been forgotten in Britain at some point between the Napoleonic Wars and the Great Depression.

'When I first went to France in 1946 the food was revelatory: just simple things in an ordinary restaurant, such as a tomato salad made with fresh tomatoes and a dressing with olive oil. In those days in London – at the Café Royal, for example – you would get elaborately grand food such as roasts, each with the correct sauce and so forth. I certainly ate it, being very greedy and used to school food. But looking back I don't think it can have been very good.'

English people, in fact, I put in, did not then like good food (and, one might add, in many cases still do not).

'When I was on a boat coming back from Greece in 1947, I befriended a group of what were called "distressed sailors". That is, sailors who had become stranded because of a bankruptcy or something. They were travelling steerage, which was more or less my class, and very frequently they complained about the food, which certainly was disgusting. An egg, for example, tasted as if it had been cooked in old hair oil, that kind of thing. So I said that when we got to Marseilles, which I knew a bit, I'd take them to have some really nice food: good eggs, cooked in butter, and so on, what the French call *cuisine au beurre*.'

'Well, we did that, but I could tell that they weren't enjoying it much. Finally one of them said [LF puts on a cockney accent]: "The thing is, Lu, we don't like food with all them flavours in it." I think that really was the old-fashioned English view.'

LF, on the other hand, likes plenty of flavour in things, or – more precisely – he wants them to have their correct true taste. He doesn't like partridges, for example, that have been reared, and consequently resemble chicken in their mildness, rather than having lived in the open. 'One of the reasons why I eat game is that I like the way it tastes wild.'

But preferences in food, as in art and life and everything, come down to a mystery of individual temperament, emotion and mood.

'In the end, one can't explain why one likes food in a certain way, just as in the end you can't say why you like a certain person, because it's always possible to imagine another person behaving in the same way, doing the same things, and not liking them.'

'For example, I like spinach served without oil or butter. Even so, I can imagine that if a woman I was in love with cooked spinach with oil, I would like it like that. I would also enjoy the slight heroism of liking it although I didn't usually enjoy it served in that way.'

2 January 2004

It is a cold day at the beginning of the New Year. LF has once more become chilled through while painting the horses at the stables. What he said about feeling different every day is matched by his appearance: he actually – now I come to notice it – looks rather different from one sitting to another. Today, for example, he has a stern, eagle-like appearance. Sometimes he looks much older, sometimes much more vigorous – even the texture of his hair seems to change.

I mention this, he answers: 'Well, I'm not surprised. And if you look different I think you must be different, because what you look like *is* you, isn't it?' This is certainly a basis for portraiture, if true. At present I am researching a book on Van Gogh, and throw into the conversation his view in a

Self Portrait, Reflection (work in progress), 2004

letter to his youngest sister from 1888: 'First I start by saying that to my mind the same person supplies material for very diverse portraits.'

In fact, now I come to think about it, LF's self portraits are very unlike each other, although from time to time at a certain angle or at a particular moment he will suddenly resemble one or another (p. 78). Is the difference between his pictures of himself to do with looking different every day? 'Partly it is, yes, but partly also to do with not wanting to have a signature.'

In other words, he doesn't want to turn out 'Lucian Freuds'. He tells a story about Henry Moore. 'I went once to see him in his studio at Much Hadham and he was doing a whole series of drawings, spread round the room. He was adding a touch to one here and a touch to another there. Not that that is necessarily a reason for their being bad, but they were bad. I'd hate the idea of turning out *artwork* like that.'

LF's aim is to make his pictures look as unalike as possible, as if they had been done by other artists. Actually, of course, his work is utterly distinctive and would be hard to mistake for that of anyone else. But it is true that there are constant, deliberate, variations of scale, handling, and angle of vision.

In his self portraits he is remorseless in recording and even gleefully seizing on signs of ageing and time. Of course, we take it for granted that Rembrandt did the same – recording his drinker's nose and flabby cheeks. LF's attitude to other sitters is in this way the same as his attitude to himself: sympathetic but clear-sighted scrutiny. As far as LF is concerned, this lack of self-indulgence is part of being a good artist.

Jean-Siméon Chardin, *Self Portrait*, 1771

'With bad painters all their pictures look like self portraits, except the actual self portraits, because they have given themselves such special regard. But on the contrary, Chardin's pastel self portrait (p. 80) – which looks wonderful – seems to be of someone he's just come across.'

. . .

About LF's complaints of tiredness, I say that he asks a lot of himself. 'But in the end, of course, it's all just self-indulgence,' he replies, 'I'm just doing what amuses, interests and entertains me most.'

Then, unexpectedly, he begins talking about his attitude to his own work. Evidently, for him the excitement is all in the actual making of the picture. 'I think half the point of painting a picture is that you don't know what will happen. Perhaps if painters did know how it was going to turn out they wouldn't bother actually to do it. Painting is rather like those recipes where you do all manner of elaborate things to a duck, and then end up putting it on one side and using only the skin.'

'When a painting is finished, I often look at it and wonder what all the trouble was about. So, for example, I didn't feel downcast at all when the director of the Tate rang me up to say that my portrait of Francis Bacon had been stolen. In general, I don't like to see my work after I have finished it, although sometimes I go to the houses of people who own my pictures, and I can't blame them for hanging them on the wall.'

I think that reversal of feeling is common. Writers certainly experience it, or at least I personally find it hard even to look at something I have written at the point when it is printed. All I want to do is think about the next piece or book.

Jazz musicians have told me that they hate listening to recordings immediately after they have made them. Then, they can hear nothing but mistakes: a few years later, they may sound fine. Similarly, when an old painting of his comes up for auction, LF will go along and take a look at it, perhaps getting a pleasant surprise. On the other hand, there are certain pictures, one suspects, that he would rather remained in oblivion. The main point, anyway, is to try to do better next time.

'When one is trying to do something immensely difficult, I think the most dangerous thing would be to be pleased with one's work simply because it is one's own. One wants every picture to be better than its predecessors; otherwise, what's the point? Even so, I will admit that there is a tiny bit of my mind – which I think we all have – that believes, just possibly, my things are the best by anyone, ever.'

That combination of rigorous self-criticism with a touch of megalomaniac ambition is part of the necessary mind-set for an artist such as LF. It helps to keep him working, hour after hour, day after day, at the age of eighty-one.

6 January 2004

I begin to feel a slight apprehension as to what this picture will look like. Will I look ugly? Will I look old? Facing up to the facts of life, such as ageing and mortality, are precisely the point of LF's type of painting – of course, we applaud it in Rembrandt, but I'm not sure how I feel about the policy when it is applied to myself. The sitter's vanity is a wild card in the history of portraiture, often – in fact, almost always – a factor

when the subject is paying for the result. But at the same time it can be a stumbling block, making for bad, dishonest images, or at the least something the painter has to overcome.

Is it important that the picture should resemble the sitter? LF observes: 'Likeness in a way isn't the point, because whether or not a painting is a good likeness has nothing to do with its quality as a picture. For example, Rembrandt's people all look alike in that they all have spiritual grandeur. You feel that he did not steer very close to the actual appearance of the sitters.'

On the other hand, LF is undeniably interested in the question. Often, he will mention that he thinks a certain picture is 'like', or 'very like'. After all, though the goal is to paint as good a picture as possible, his raw material is quirky individuality in the appearance of a certain person, animal or thing – in the case of the current painting, me.

When LF was painting *Self Portrait, Reflection* (p. 84) in 2002, his cleaning woman glanced through the studio door one day and saw it on the easel in the shadows, and told him: 'I thought it was you.' He was pleased and amused by this incident, which recalls anecdotes in Pliny in which the unwary try to draw painted curtains, and doves attempt to peck the grain in a still life. An ancient aim of figurative art is to convince, even deceive, the viewer.

. . .

This evening LF spends a good deal of time mixing bluish-silver with a touch of yellow, which I correctly guess is for the hair on the sides of my head, now grey. Someone said to me at the beginning of sitting for this picture, 'That's a brave thing to do!' But until now I have not had any qualms about the possible result.

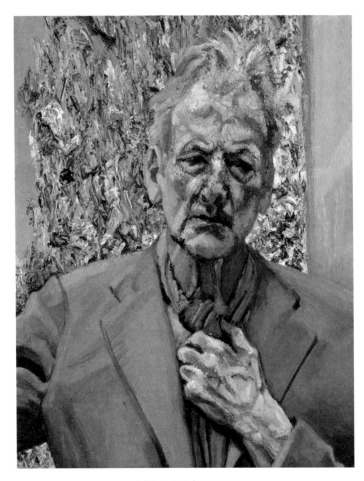

Self Portrait, Reflection, 2002

The painted area now extends – almost – to the tip of my nose and up as far as the hairline. It is coming on, and so far, I suspect, looks very much like me. LF says that it is unusual for him to follow his original drawing as closely as he is in this case. On the other hand, the painting is now beginning to divert to the right. My drawn nose goes one way, my painted nose the other.

...

This evening we go to Locanda Locatelli, an Italian restaurant near Marble Arch, for supper. Over the meal, we talk about Lord Byron, getting onto the subject via punctuation. I say his way – entirely by dashes – is idiosyncratic but good. LF agrees: 'It's characteristically generous, leaving you the reader to do it how you like in your head.' He loves Byron's *Don Juan*. 'It's just a long catalogue of gossip with terrific puns and humour.' He also much likes Molière's *Don Juan*, which he says is marvellously amusing and presents the hero as a complete psychopath, which isn't how you normally think of the character of the great lover. 'I wonder', he muses, 'whether my grandfather knew it?'

It's an intriguing speculation. LF seldom mentions Sigmund Freud, but when he does it is always affectionately. 'My grandfather, who died when I was about sixteen, always seemed to be in a good mood. He had what many people who are *really* intelligent have, which is not being serious or solemn, as if they are so sure they know what they are talking about that they don't have the need to be earnest about it.'

LF, too, is very fond of humour, including a number of comic songs in his repertoire, and also comic poetry. His appetite for

stories about people's quirks and foibles is enormous, and also for witticisms. Characteristically, he makes distinctions about the psychological flavour of comedy. On Oscar Wilde, he notes, 'He had what is always very attractive in anyone, which is self-indulgence carried to extremes. Wilde's wit was completely un-malicious, whereas Whistler's was the reverse, completely malicious. Un-malicious wit is always much funnier because it can be playful and fantastic.'

Moving the conversational theme back to painting, I tell him how a few years ago I went to Lille to see an exhibition of paintings by Goya – a wonderful, beautifully selected exhibition. One of the pictures on show made a big impression on me: it was of a man peering down the throat of a boy (p. 87). The subject, it has been discovered, is taken from *El Lazarillo de Tormes*, a sixteenth-century Spanish picaresque novel. This is narrated by Lazarillo, who becomes the servant of a blind swindler. One day, while grilling the sausage for his master's supper the lad is overcome by greed and wolfs it down himself. He gives the blind man a turnip between two slices of bread as a substitute, but the trick does not work for a second. The swindled swindler uses his sense of smell to track down the missing sausage, yanking open the boy's mouth and poking his long, sharp nose into it to sniff out his supper – with the unfortunate effect that the victim gags, and the chewed up, half-digested meal is returned to its owner. The painting shows the moment before that happened, the boy with gaping jaws, the blind man's fingers inside, feeling for the sausage.

I suggest this strange and wonderful picture gives a clue to Goya's own sense of humour – sardonic and very black – and the way that many of his works may well have been intended. By coincidence, it turns out LF had come across the very same painting, many years before.

Francisco de Goya, *El Lazarillo de Tormes*, 1808–12

'When I was in Madrid in the early 1950s with Caroline [LF's second wife, Caroline Blackwood] she fell ill and I was recommended to a specialist by the Madrid correspondent of an English magazine. This doctor turned out to be rather like my grandfather, you know, a Herr Doktor Professor. He lived in some style. In his apartment was this Goya, which was then called the *Tonsil Operation*, but must have been the one you saw. It was at once dreadful and funny. I've never forgotten it.'

'Goya is one of the most mysterious of painters. For me, his prints and graphic work are enormously more interesting than his paintings. But all his work is filled, as so much great art is, with a sort of jokiness. You find the same thing in Ingres, in Courbet, in anyone who is marvellous. Their work is filled with jokes.'

Is there humour in LF's work? Certainly there is plenty of larkishness in the early drawings, *Galloping Horses* (1940), for example. *The Painter's Room* (1943–44; p. 89), with a gigantic head of a Zebra sticking through the window, is somewhere between surreal and humorous. And the later work? I think there is jokiness there sometimes too, though more deeply buried. The contrast and comparison between the bare-breasted woman and her canine companion in *Girl with a White Dog* (1950–51) is all sorts of things: disquieting, tender, erotic. But it is also a bit funny.

16 January 2004

L F has been painting the horse's back and hindquarters again. He reports: 'It's getting really wild.' We talk for a

The Painter's Room, 1943–44

long time before the sitting about LF's early days in Paris. It is a counterpart to his sojourn in lowlife Paddington: a vignette of existence at the rarefied summit of high society. Evidently, LF found it fascinatingly odd.

'When I first went to France, the *poste restante*, as it were, was some old friends of my grandfather's, Princess Marie and Prince George of Greece. I used to go there once a week for a meal; I had never eaten in such grand circumstances before. A lot of people in those days had servants; but there the people who served at table had white gloves, that sort of thing. They had a lot of bad portraits hung on the walls of the dining room. His on one wall, hers on the other; I asked them the reason for this arrangement.'

'He explained: "We like to look at our ancestors while we are eating."' (LF makes a gesture of amazement.)

'One day, I don't know why, I looked in their cellar, and as well as wine, they had a lot of pictures leaning against the wall. I saw one of them was a Goya. They had marvellous things, but to them they were just something to put on the walls. They had another house at St Cloud, which is about as far away as Hampstead is from west London, and there, the Princess told me, "it's much more formal".'

'The food was perfectly delicious. Quite often the vegetables would be a whole course on their own, but perfectly done. I'd never eaten like that before. But they were absolutely out of touch with ordinary life. The Princess would say for example, "We've got something very special today, just in season" and it would be cherries. But I went every day to Les Halles, the old one of course, and there, there were stalls as big as this room piled high with cherries.'

'The Princess was very unworldly. Once I ran out of money, so I asked her whether I could borrow some. And she said, "Yes, how much do you want? Do you want 10 francs, 100, 1,000? 10,000?" As if it were just a commodity like sugar and she just wondered how much I required of it.'

There is a Proustian sweep to LF's experience of the world, and also his range of sitters. He has painted aristocrats – the Duke and Duchess of Devonshire, Baron Thyssen, Jacob Rothschild – but also burglars, Soho drunks, artists, writers, a jockey, several bookmakers, in fact a whole gallery of individuals who appealed to him as subjects for one reason or another. The categories of people who seem not to intrigue him are those who are playing a role – not themselves – and those who lack any intensity of personality: the nondescript.

...

A certain range of colours is characteristic of LF's work – oatmeal, greys, whites, beiges, light yellows, creams, browns and blacks. He once called them 'the colours of life', and one quality they have in common is that they don't call attention to themselves. His house and his clothes are the same. LF dresses for the most part in that same range of grey and cream shades. Nothing shouts. In contrast, some other painters favour flamboyantly bright hues in both their work and their surroundings. Such matters, LF points out, are a product of temperament: 'In the end, nothing goes with anything. It's your taste that puts things together.'

His own taste is strong and individual. When the workmen were removing the upper layers of paint and paper in his sitting

room, he told them to stop at the point when the original Georgian plaster was revealed. The choice reminds me of his taste in unadorned – and often unclothed – people. Once, after meeting a woman, he complained about the amount of make-up she had worn: 'I felt I couldn't see who I was talking to.'

If one examines his paintings closely, however, they are more richly marbled and veined with diverse hues than is apparent at first glance. When sitting, I often find myself wondering what a certain colour is for. This evening, a greeny-grey is carefully confected, with much close examination of my features. Then, quite quickly, it goes on. What could it be for? My sideboards? The shadow beneath my cheek-bones? When LF says 'Stand up and take a stretch if you like', I see it was for my upper lip, which is now arranged, butterfly-like, on a piece of blank canvas beneath my nose. 'You've given me a moustache,' I observe. 'Yes,' Lucian replies with satisfaction, 'it's a lovely green colour.' Today the tip of my nose has also appeared.

. . .

The face, which LF and so many others have spent so much time scrutinizing and transforming into marks on canvas or paper, might seem to be a restricted sort of subject. After all, everybody, barring accidents, is issued with the same complement of two eyes, one nose, mouth, chin, and so forth. In reality, nothing could be more varied in its topography.

From a book that I am reading – *The Face* (1999) by Daniel McNeill – I learn that in the late 1980s a scientist at the Massachusetts Institute of Technology Media Lab worked

on a project for the identification and analysis of the human visage by computer. He was called Alexander Pentland.

Pentland isolated one hundred different component portions of the face, dubbed 'eigenfaces' from the German word *eigen*, meaning 'individual'. Some of these zones of facial territory are more obvious than others. The upper lip, today provisionally blocked in on the canvas, constitutes one of the hundred; others consist of more varied chunks of cheek and jaw. According to Pentland's study, each of these hundred pieces in the physiognomic mosaic can vary in a hundred detectable ways.

Thus the total range of possible variations in the human features, in mathematical terms, equal 100 to the power of 200. This is, according to McNeill, a number considerably greater – meaning many more zeros on the end – than the number of subatomic particles in the universe. It is, as McNeill puts it, 'a preternatural sum, far beyond any human sense of infinity'.

Furthermore, this terrain of the face is one to which human beings are attuned to an astonishing extent. Dedicated areas of the brain are devoted to the recognition of faces and the decoding of their expressions.

These are the physiological and psychological facts that underlie the art of portraiture. They begin to explain why, as a genre of art, it is of such perennial interest. So much so that we look with fascination at the faces of people we do not know, dead for hundreds of years, who are often no more than a name. Even a name is not necessary; we are perfectly happy with *Portrait of a Man* or *Head of a Woman*, which is effectively the title of many of LF's pictures.

...

LF is going to Kate Moss's thirtieth birthday party later this evening, which is at the art dealer Jay Jopling's house near Portland Place. Moss is a friend of LF's, and at one stage a sitter for a naked portrait when pregnant. We meet LF's daughter Bella and her husband at Locanda Locatelli, who are also invited. Both LF and I eat langoustines.

23 January 2004

L F is looking rather fit and vigorous. He has not been painting at the stables, but went over there to look at another horse that he was considering as a sitter. But somehow, when he looked at her again, he couldn't find any interest in this mare.

'It was like looking forward to meeting someone, and then, when you do, thinking, Why on earth did I want to see you? She had had a sort of amused look when I saw her, from the side. But this time, when I looked at her again, that had gone. It sounds mean, but I found myself thinking, Why does your body go on for so long? There seemed to be no muscles in it, no forms, nothing.'

Instead, he thinks he will do another picture of the skewbald. In the meantime, he has asked the waitress whom he has had his eye on if she would be willing to pose, and she immediately accepted. She will start next week.

...

The Kate Moss birthday party apparently went on until eleven o'clock the following morning. 'But I stayed for only a short time. I had twenty minutes of intensive dancing.' It is part of LF's bodily nature to be agile and nimble. He is a small, nippy person, quick on his feet, which may well be why he is still, in his early eighties, capable of standing at the easel for hour after hour, bobbing back and forth. Dancing, like horseriding, is among his pleasures.

I tell LF that I met Damien Hirst the other day, who is one of the subjects of a series of interviews I am doing for the *Daily Telegraph* magazine. Hirst said that he bumped into LF at the Kate Moss party, and that LF once asked him to pose. I suggest that would be a good idea: it's a picture I'd very much like to see, an addition to LF's gallery of fellow artists, which already includes portraits of Bacon, Frank Auerbach, John Minton and Michael Andrews.

Hirst is still mulling over a remark made by LF about *A Thousand Years* (a work from 1990 which had also impressed Francis Bacon). It consists of a vitrine – glass tank – containing on the one side a rotting cow's head on which flies constantly breed, mate and lay their eggs. On the other side is an insect-o-cutor, one of those blue lights one sees in butchers' shops, which kills flies. It is a neat and grim metaphor for the cycle of life, including human existence, hence the title.

When LF first saw it, he said to Hirst that he had started with the final act. 'Oh, yes,' he recalls, 'I did say that, thinking of operas.' Damien Hirst is musing about paint just at the moment, and has told me his reflections on this perennial medium. 'I decided that a layer of paint on the surface of a

canvas is just the same as an object in the room. You know, the deliciousness of it, the thing that makes you love the painting, is a physical thing, the building up of layers. You want to eat it, as if it were ice cream or something.'

I pass on an intriguing observation of Hirst's about LF's pictures: 'What I love about Freud is that interplay between the representational and the abstract. His work looks so photographic from far away, and when you get up close it's like an early de Kooning. You can always tell a great painting because when you get close there are all these nervous marks.'

LF is pleased. 'Oh, I like that. It's like the people in Paddington saying, "Lu, your work is funny. When you look at it from a distance you can see what it is, but when you look at it close to, it's a complete mess."'

He continues on the theme of brushwork: 'In a way I work the way I do because I can't see what I'm doing. I decided long ago not to wear reading glasses when I painted, although I do when I make etchings because that is very close work. It's only by stepping back that I can see what I've been painting, so it's more like aiming at a target while I'm actually putting the paint on. But I'm sure if I wore glasses it would affect the way I paint. Also, I don't use my left eye very much; I have something called a lazy eye, which was discovered too late to correct it. I'm right-eyed, which is often the case with people who are left-handed, like me. It's a sort of compensation.'

It strikes me that short-sightedness, and the need – or not – for glasses and other optical aids, is an underrated factor in the history of art. This suggests a new explanation for late style, the broadening and loosening of brush strokes, as in the works from the old age of Titian and Rembrandt, whose splatters and dabs of pigment are sometimes astonishingly free.

Surely both of them must have been long-sighted – as virtu-
ally everyone with normal vision is – by the time they reached
their fifties. Conversely, the minute detail in the work of Van
Eyck could only have been achieved with the use of a lens,
perhaps a magnifying glass.

It is an important fact about LF's paintings that they are
done entirely by natural vision, his own idiosyncratic way of
seeing. They are not seen through a lens; nor are they depend-
ent in any way on the camera-eye view of the world – as many
figurative paintings have been since the time of Daguerre, and
more and more so today. Although LF admires the work of
some photographers – Henri Cartier-Bresson, John Deakin –
he feels the medium has little in it to help him as a painter.
Photography, he says, provides a great deal of information
about the fall of light, but not about anything else.

. . .

LF's work became free, however, many years before middle-
aged long-sightedness would have affected him. The change
began in the late 1950s, when he was still in his thirties. He
explains this startling mid-career change of style as the result of
a typical desire not to do what people expected of him. 'At that
time I had an exhibition of paintings I had deliberately made
much more free. I suppose I was influenced by the critics, in a
way. People used to write: "He is a fine draughtsman, but the
paintings are rather flat." I thought, I'd better put a stop to that.'

That is, of course, a way of saying that he himself wanted
to make a fundamental alteration in his work: transforming
himself from a painter whose work grew out of drawing, to
being a painter whose pictures were not graphic but fashioned

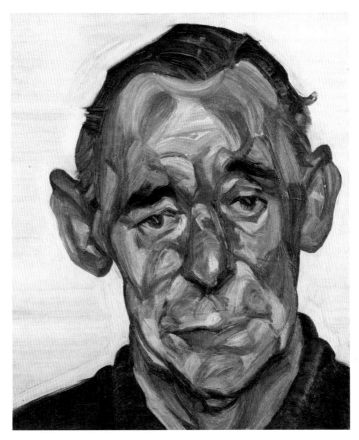

John Deakin, 1963–64

in ways that can only be accomplished with paint and loaded brush. He had concluded that those critics of sixty years ago had a point. His early paintings were intimately connected with his drawings, so much so that a drawn portrait such as *Girl with a White Dress* (1947) has much the same qualities as his oils of the same date.

The difference between his work before and after this change of approach can be seen by comparing, say, LF's portrait of John Minton (1952; *see* p. 117) with the equally remarkable *John Deakin* (1963–64) from a decade later (p. 98). The former is so sharply defined that one feels one could count every hair of Minton's head; the latter is so broadly executed that, on the contrary, you see the marks of the bristles of the brush in the broad scoops and whorls that make up Deakin's face.

In art historical jargon, LF decided to metamorphose from a linear artist to a painterly one. To switch style abruptly like this was a characteristically audacious, even foolhardy, thing to do. Indeed, it alienated one of his strongest and most influential supporters, Kenneth Clark, former director of the National Gallery.

'After the exhibition opened he wrote a card saying that I had deliberately suppressed everything that made my work remarkable, or something like that, and ended, "I admire your courage." I never saw him again.'

After that change, the most radical in his long, long career, LF gave up drawing – more or less – for many years. Instead, in the 1960s he made watercolours – even looser and splodgier than his oils – and in the 1980s, pastels. In both cases, he seemed to be trying to find a new way of working on paper in accord with the radically altered way of painting he had developed –

one that in the long run was not quite the answer he sought. The watercolours, such as *Child Resting* (1961) and *Sleeping Girl* (1961), are more broadly handled than the broadest of his oils of that date. But they are also, if one can put it that way, the least Freudian of his works.

The medium of pastel, which he tried next, is *par excellence* that of a *painter* working on paper, as used by Degas, Manet and Chardin. LF's pastels, such as *Lord Goodman* (1986–87), were beautiful but also – perhaps – a dead end for him. Several were closely connected with etchings. Two versions of *Cerith* (1989) were actually done over the etching of the same subject. In the long run, etching was the medium LF stuck with.

From the 1980s onwards his etchings have the precision of surface detail natural to this medium, combined with the sense of mass, force and plastic power of his paintings. In fact, they are a complete answer to those critics of yesteryear. Looking at his etchings, you can tell what a great painter he is.

Often, having painted a portrait of someone successfully, LF likes to go on and do an etching. This is something he may want to do in my case, and a possibility to consider. Do I want to be etched, indeed, could I stand to begin this process of sitting all over again when – and if – this picture is ever finished?

26 January 2004

I arrive early, or rather promptly, at six, having interviewed Sarah Lucas – another of the artists I am writing about for the *Daily Telegraph* magazine – on the other side of London, in Hackney, and had a long peregrination to LF's studio by train, bus and Tube.

It is very cold, and getting colder. LF is not painting at the stables until it gets warmer. He has a proof of the print of his model – one I have never met – who is a quarter Afro-Caribbean. It has come out extremely soft and silvery because the wax started to rise off the metal after a quarter of an hour in the tank of acid, meaning that instead of just biting LF's incised lines it would eat into the whole surface. The printer had to whip it out (forty minutes is the norm). This is the second time such a thing has happened to LF in the last two years. The first time the etching – perhaps a hundred hours of work or more – was completely ruined, a strange experience he says: 'Not so much wasting your time as having your time wasted for you.'

Printmaking seems more subject to the vagaries of chance than I would have imagined. LF is still a little dubious about this rescued, lightly bitten etching. 'At first I couldn't look at it and it still somehow has the look of not being my work.' That is true, it is delicate in the manner of a fifteenth-century drawing in silverpoint, but still it looks very beautiful.

. . .

Something has gone wrong, LF says, with everything he did with the model with fuzzy hair, except the etching of her – and even that had almost been ruined by the acid (pp. 102, 103). As the poor girl had given up a job in a shop to pose, it must have been very discouraging for her (though the print is, I think, wonderful). LF comments: 'When things go wrong I become superstitious, if they are going well I accept it, I feel it's normal. If not, I begin to look for reasons.'

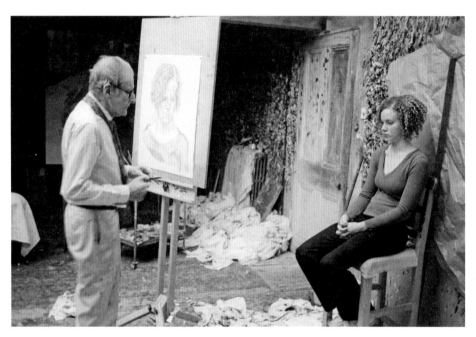

Girl posing for the etching, *Girl with Fuzzy Hair*, 2003

Girl with Fuzzy Hair, 2004

Quite large numbers of LF's works founder. From time to time, a half-finished picture turns up from the recesses of one of the studios, and he takes another look at it. He says of an unfinished self portrait – begun, from the look of his dark hair and more youthful face, decades ago – that has emerged in the studio:

'It looks promising and I've taken it up again on occasion. But whenever I did, I realized why I'd not carried on in the first place – in the same way that a specialist might say of a child, that one's not going to grow up right. I could tell that it wouldn't develop into a finished picture. There's something wrong. I have lots of paintings in my studio that didn't work. I feel in a way having them around keeps me going. One painting may go wrong after four days, another after longer.'

. . .

Towards the end of the sitting, instead of working in a carefully measured manner, LF starts to apply dark paint in long, sweeping, downwards strokes. 'I tell you what, I wouldn't mind shrinking it a bit' – it being my head. When I look at the canvas, a large, irregular dark patch has arrived, encroaching from the right.

An anxiety has surfaced at the back of my mind: What if this portrait of me goes wrong and the whole marathon of sittings turns out to be wasted? What if he suddenly loses interest in me as a subject, as he did in the horse he decided not to paint?

In the morning LF phones to confirm the sitting. It has snowed overnight and he is excited. 'The trees are all wearing their white jackets and the streets are full of snow. It's amazing.' If lack of enthusiasm about snow is a sign of growing old, by that test, at least, LF is still young.

The studio is transformed. The painting of the nude with cherries, the setup for which has been a feature of the place for so long – with the tail of fluff escaping from the pillow which was on no account to be disturbed because it was posing – is finished and turned to the wall. LF says that's because he does not want to think about his paintings once they are over. But it is a little disconcerting. A presence has gone; a micro-world disappeared. The whole room has been cleaned and swept, and the floor washed by Lucian's stepson Kai ('if you can have a stepson without being married'). The mound of rags in the corner has gone too.

. . .

LF takes a break and sits down, as is now possible, on the bed where the nude with the cherries used to recline. He starts talking about a painting, now lost, which he did in the 1950s of an antiquarian bookdealer called Bernard Breslauer.

'He was absolutely repulsive to look at. I remember he used to go often to Muriel's [The Colony Room, a Soho drinking club], and once a very drunk woman bumped into him. When she got a look at him, she said: "You've just ruined my day." But he had some discrimination, he had a drawing by William Blake for example; he had some very nice things.'

'He suggested I should paint him, and one day during a sitting I must have become agitated as I always become agitated when I paint, and I must have muttered, "That's lovely!" He immediately objected, "You shouldn't have said, 'That's lovely', you should have said, 'You're lovely!'"'

'I thought' – here LF crosses arms in an indignant pose – 'Right, that's it! So I made him even more repulsive than he actually was. He was made of green, flabby, soft stuff – his flesh – and I made him wear a roll-necked pullover so that his jowls drooped over it in a horrible way. When I had finished the picture and sent it to him, he sent me a letter saying that I had contravened an unwritten contract between painter and sitter. Well, if there were such a contract, that's exactly what I would want to do – to contravene it.'

Nonetheless, it seems that in this case LF had contravened one of his own private guidelines. It is very unusual for him to work from someone with whom he does not have a degree of sympathy – as he had, initially, in this case. It sounds, though, as if during the process of sitting, irritation with the subject took over. LF, though he would like to see the painting again, has misgivings about how it turned out. He suspects it was 'a bit cartoon-like'.

'Later, when we were doing an exhibition, we sent Breslauer a letter asking to borrow it – he had moved to New York. He replied saying that he had no such object in his possession. But I would have thought that because it was by then valuable, and it was of him, he wouldn't have destroyed it.' Pause. 'That picture is somewhere.' [In fact, it turned out that the portrait had indeed been destroyed by the sitter. 2009]

There is, implicitly but not necessarily, a clash of interests between the artist and the portrait's subject. The potential

point of disagreement is of course the image of the sitter. The artist wants the painting to be as powerful and interesting as possible; the sitter perhaps wants that too, but can hardly help also wanting to look good personally in it.

Part of the problem is that few of us actually know what we look like. In the past, this could be simple ignorance. A nineteenth-century London street photographer told Henry Mayhew, the Victorian chronicler of the lives of the poor, that in his experience, 'People don't know their own faces. Half of 'em have never looked in a glass half a dozen times in their life, and directly they see a pair of eyes and a nose, they fancy they are their own.' This man was in the habit of preparing images of strangers in advance and fobbed them off with success to his customers.

In the case of more sophisticated sitters with better access to mirrors, the problem is more likely to be self-delusion. We arrange our features pleasingly in the looking glass, pull in our stomachs, present our best angle, and presume the result is the truth. Photographs that do not correspond to that appearance, we dismiss as accidental misrepresentations.

LF is ruthless about such sensitivities on the part of the sitter. Andrew Parker Bowles, he told me, had protested about the way his stomach protruded from his open jacket in the full-length portrait next door. 'He complained a bit about it, so I thought I'd better emphasize it more.'

He continues with the process of 'shrinking my head', which is clear evidence that the picture is – like any work of art, in words, paint, stone or any other medium – an entity that follows its own inner laws. In this case, it is a matter of proportion, which is a question entirely separate from whether the picture looks like me, doesn't look like me, flatters me, or the

reverse. 'You are here', he says firmly, 'to help it.' The implication, surely correct, is that the portrait and its needs come first.

In 1954 LF wrote that 'the picture in order to move us must never merely *remind* us of life, but must acquire a life of its own, precisely in order to *reflect* life'. This hints at one of the oldest feelings about figurative art, reflected in the myth of Pygmalion – the sculpture that stepped down from its plinth – and before that, those Egyptian statues waiting in the darkness of the tomb to receive the souls of the dead.

3 February 2004

I arrived today from interviewing Carl Andre, the American minimalist sculptor whose *Equivalent VIII* (also known as 'the Tate bricks') once created a huge controversy. One might think to take a taxi from tea with Andre to LF's studio involves a tremendous change of mental and artistic gears, but even so LF turns out to be quite interested in him. Andre has a trait that is both highly eccentric and in a way the absolute opposite of LF's interests as an artist: he resolutely refuses to have his face photographed. No catalogue or monograph about him contains a portrait of the artist. No one, except his friends and acquaintances, knows what he looks like. He is an anti-portrait artist.

I say at the end of the sitting: 'I keep turning up wearing this blue scarf, but you never get anywhere near it.' Indeed, for several sittings now, the painting has seemed to progress very slowly, if at all, while LF carries out a process he calls 'strengthening your upper face and hair'.

'Yes, but I am always aware of the scarf. I am painting the face using very varied colours, because when the scarf goes in they will all turn monochrome.' The blue, in the context of LF's work, is an exceptionally bright, saturated hue. Evidently, he has been mulling over how to make it fit in.

This brings out the extent to which LF has a strategy for the painting, despite his insistence on not knowing how his pictures will work out. Of course, the two are compatible. The development of the picture may fluctuate from sitting to sitting, but evidently right from the beginning LF has had the royal blue in mind, and has known that everything else on the canvas must be related to it, as the whole development of a piece of music might depend on a crucial passage in a certain key.

LF pays as much attention to the mixing and choice of the pigments as to placing them on the canvas. At present, the variety of the colours he confects is startling; I continue to spend a good deal of time guessing, often wrongly, what part of me they are destined to be. The mixing is done for the most part very delicately, with the tip of the palette knife, a tiny quantity of red, say, in a large dollop of white. (LF complains that he will not be able to get any more of this kind of white, which comes in a tin, because of some EU regulation.) Khaki, dove grey, rose pink, even lime green and patches of gun-metal grey, are all assembled and added to my face.

If you look at one of LF's paintings of a person from close up, it dissolves – just as Damien Hirst remarked – into a pattern of marks and hues, like a desert seen from above. These are not flat, but so to speak directional, the traces of the bristles remaining visible like lines of force. Raised speckles and ridges stick out like outcrops of rock, catching the light. A few square inches of this patchwork seems attractive but perfectly

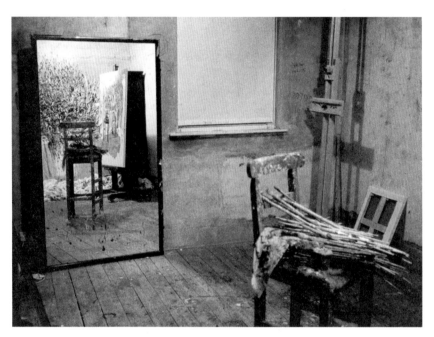

The studio in Holland Park, 2004

abstract. Move back a little, and all this metamorphoses into the rounded forms of skin and flesh over bone.

LF is, as one might imagine, highly interested in pigments – the differences between them and how they behave. 'I once read a book by Max Doerner, *The Materials of the Artist and Their Use in Painting*, which is full of the most marvellous information on pigment. There is one, Kremnitz white, of which he says something like, "this I hesitate to recommend because it's so poisonous" – because it's almost pure lead.'

Kremnitz white is twice as heavy as flake white; you could call it an extreme pigment in the way that people talk about 'extreme sports'. It lies on the border between artistic materials and chemical engineering. In his book on LF, published in 1982 – my own introduction to Lucian – Lawrence Gowing made interesting observations on LF and Kremnitz white. 'It coagulated in little lumps which accumulated more of the drying paint until the surface was coarsely granular.' This roughness of texture is characteristic of LF's work – or some of it – and gives it a unique quality, at once heavy and shimmering. Gowing wrote: 'In *Pregnant Nude*, for example, the light itself seems to granulate as it falls on the thighs, with an incandescence that is very responsive to the richness of flesh.'

LF is offhand about this sinister sounding pigment. 'Well, I used it for years and it never did me any harm. Of course, I didn't eat it. If I worked in such a way that the paint flew about it might be different. Francis [Bacon] used to mix paint on one of his forearms, then developed an allergy or something and couldn't any more.'

He said some memorable things to Gowing about how he wanted his paint to '*work as flesh*'. '"I know my idea of portraiture came from dissatisfaction with portraits that resembled people.

I would wish my portraits to be *of* the people, not *like* them. Not having a look of the sitter, *being* them. I didn't want to get just a likeness like a mimic, but to *portray* them, like an actor." (*Portray* was said with a peculiar intensity.) "As far as I am concerned the paint *is* the person. I want it to work for me just as flesh does."'

6 February 2004

I am feeling rather tired, as I tell LF. He replies that he could see that from my eyes, when I first arrived, but now they are back to normal. A person's energy levels are just one of numerous pieces of information that can be detected from looking at the face.

LF tells me he met John Gielgud just once in his life, when he was waiting for a lift. 'He came out of the lift door, and said, "You're looking very well!" I replied, "How could you possibly tell? You've never seen me before." JG: "That's got absolutely nothing to do with it."'

Gielgud had the better of the exchange, because looking well is a physical condition that can be observed in a stranger; it is necessary to know a person only to detect if they are looking better or worse. Weariness, and illness, can be seen even in someone unknown.

'I've had a dodgy few days,' remarks LF, who is perhaps looking a little worse than usual. One dodgy thing is that the new model, the waitress, did not work out. A few days ago when I arrived there was a charcoal drawing, a large nude with her knee drawn up. LF had felt that things were going so well that he almost started putting paint on, an extremely positive

sign at the first sitting. 'Except I felt it was like going a bit far on the first date, when you've only just met.'

But at the next sitting, it had all gone wrong. The model turned up an hour or two late, and was unable to see what was the matter with that. 'When she did arrive, she said, "I think I'd better not sit now, you are too agitated." Of course, that was the end. It was simply a profound misunderstanding. The one thing I want models to be, in the end, is dependable.'

'I think a lot of my sitters are girls who have some sort of hole in their lives that is filled by posing for an artist. I think it also helps if in some way, no matter how nervously, they are pleased with themselves, with their physical appearance. But in the end, what I really need is dependability, for them to carry on turning up.'

There are many pitfalls for LF and his models, especially the young women. They may not realize the sheer commitment of time involved, the extent to which the whole exercise is an endurance test, or may simply be too rackety to manage the reliability and punctuality required of them. Perhaps they get a boyfriend, want to travel or have a social life – anything except spending hour after hour in the same position, motionless in the studio. Or, on further acquaintance, he might not like them, or the sitter might not take to him.

The process is so remorselessly intimate that – as in a marriage or long relationship – any small incompatibilities are likely to cause friction sooner or later. During the period of the sittings I am spending more time with LF than with anyone except my wife and children, and more time just talking than with anyone at all. It is an experience almost like returning to youth: endless time and nothing to do, for the sitter at least, except chat. I'm not sure whether it is filling a hole in my life, but it is enthralling.

I simultaneously don't want it to stop and – because the progress
is so glacially slow – can't wait for it to end.

'How long', LF asks idly, 'have you been sitting now?'

'Since November.' He is surprised: 'It seems like about ten
minutes.' But then, for him, this is everyday life; as soon as one
painting stops another starts. In the studio, there is an eternal
present. Time stops. There is always an item to examine, a
colour to mix. There is no sense of hurry. That is one reason
why it is relaxing, almost therapeutic.

On the other hand, for someone who does not wear a
watch, LF's sense of time is often uncannily accurate. He will
guess, and often be right to a minute.

'Is it about a quarter past nine?'

'Yes, fourteen minutes past.'

'When I'm on form I can usually get it very close.' I suspect
that probably also means that when the picture is going well,
his concentration and senses are sharp.

…

That evening, LF said that he had made progress, but had felt at
the end of the sitting that he was on the point of suddenly
moving forwards. I felt it was a shame we had stopped to eat,
and said that on another occasion I would have been happy with
a sandwich. But of course, the meal for LF is part of the ritual
and the process: an extra hour or two of observation.

For several sittings the portrait has not seemed to change
very much, although he has been constantly strengthening and
adjusting. At the end of the last session my mouth suddenly
appeared, if only as a thin red line. This was an indication that
Lucian was ready to move down from the frontier – roughly

across my face from my upper lip – at which work had halted a couple of weeks before, like an army held up in its advance.

Now, at last, things do move onwards. My whole mouth appears and, to my surprise, seems almost to be smiling – a very unusual expression for a Freud sitter. This image, as it gradually appears, is becoming a sort of alter ego. It is also a revelation of how LF sees me, or, to be more precise, what possibilities he sees in me to make a picture.

As I sit in the chair, there are moments when I am gnawed by vanity. How grey, I wonder, is he going to paint my hair? How much will my jaw-line sag? Sometimes I fret that my jaw is drooping forwards at what I suspect is an unflattering angle, so I surreptitiously raise it a fraction of an inch from time to time when he isn't looking.

He, for his part, is increasingly concerned about the angle of tilt of my head, from side to side. At the first sitting I must have inclined it to the right, but now half the time I instinctively lean it a little to the left, so that twenty times a sitting, LF stops and says, 'Could you turn your chin a little to the right. No, that's too much. Now that's very good.'

11 February 2004

L F is struck that only the other day, the previous Friday, we had been talking about his cousin Walter, son of his Uncle Martin, and that he had also mentioned him to somebody else. Now his obituary is in the paper. On this kind of apparent ESP, he adds: 'I once started to work from a model and I was painting her breasts one day when I had the

extremely strange feeling that there was nothing there. Two days later, she committed suicide.'

A commonplace about portraiture is that the artist sees beyond the external appearance of the sitter, sees into their mind and – if there is such a thing – soul. I mention LF's extraordinary portrait of the painter and illustrator John Minton (1952; p. 117), in which the sitter looks doomed, as though he is about to fall apart from emotional stress. Eventually, Minton also committed suicide. Photographs of him, however, reveal far less – almost none – of the inner tension and anxiety so apparent in LF's painting. But this, LF seems to feel, was not so much the product of insight as obvious.

'Oh, yes, being doomed was rather his thing. I think he must have had a plan about that portrait, because he left it to the Royal College of Art, which was where he taught. I knew him quite well, and he was very engaging and witty about being doomed. We'd be sitting in a restaurant and when the waiter arrived he would say, "Could we have a nice bottle of Château Hysteria?"'

'He left me two hundred pounds in his will, which was very nice of him. But because he was so generous, he left more than he actually had, so in the end I only got half – although that was worth a lot more than it is now, to put it mildly.'

Here is a case where the painter – or a painter such as LF who spends hours, months, even years observing his subject – quite naturally records vastly more information than a camera lens can see. It is thus a matter of accumulated experience: that is, memory. The reason why everybody sees differently is that each of us perceives a given sight from the vantage point of their own past thoughts and feelings. A painter can record this individual refraction of view in a lasting, public form: a picture.

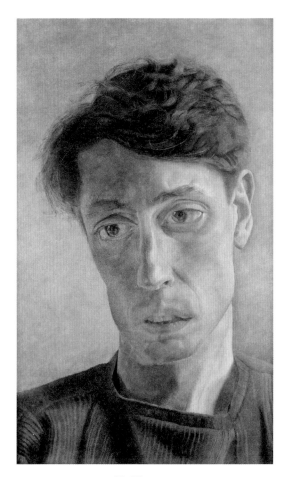

John Minton, 1952

Thus LF's portrait of Minton is a visual summary of his sense of the sitter, as a person, and a failure. 'I think he realized that he was no good as an artist. His paintings are just hopeless, the illustrations to Elizabeth David's cookery books and so on are better but still they have the air of all being of the same boy. When he was sitting for me, I remember him saying, "Lucian, when you are painting a person's portrait, you keep looking at them – really, really hard." He seemed surprised. Francis Bacon very much disapproved of him, he thought he was silly.'

LF, on the other hand, seems to have thought Minton was touching and tragic, his picture of him at once unrelentingly candid and delicately sympathetic.

...

There is a clear difference between the work and temperaments of Francis Bacon and LF, though art historically they are destined, I imagine, to be linked together rather like Turner and Constable, that previous oddly associated pair of great British artists. Bacon's emotional constitution was one that LF observed with close attention for years, Bacon being both his friend and intermittently his sitter.

'When young, Francis was not only exuberant and witty, but, in his way, wise. What Francis used to say he enjoyed most of all was "an atmosphere of threat". The reason why he painted dogs was that they were one of the triggers for his asthma, so they created the atmosphere of threat that he liked. When he was called up for the army, he rented a dog from Harrods and slept with it so that the following morning he was absolutely speechless and wheezing – not that I think

there was much danger of his being accepted. (Only from Harrods could you hire a dog for the night. Francis had a passionate love of Harrods. He used to say that it was the only shop that would accept that you had accidentally left your money behind and allow you to buy on credit.)'

'Francis once advertised in *The Times*: "Young gentleman prepared to undertake any task." At one interview, when he entered the room the potential employer was already red in the face with anger, which caused Francis to bristle with excitement. "Get out, get out," the man shouted, "I can see that you are as lazy as all the rest."'

This mind-set explains a great deal about Bacon's paintings, of animals but also of people, the power of which so often comes in part from the fact that they are frightening. They confront the viewer with a snarl or the menacing smile of a gangster. Both beasts and men tend to dissolve into a feral blur, suggesting a creature that might be about to attack.

Bacon's aim was to capture the instantaneous visceral response of encountering another living being. Quite often, his figures and animals are in movement, perhaps about to spring or lash out. He seldom worked from the live model.

In the 1960s, LF painted Bacon's lover, George Dyer. But his Dyer, *Man in a Blue Shirt* (1965; p. 120) – melancholy, reflective, a little lost – was a very different individual from the turbulent figure who appears so often in Bacon's paintings of the 1960s and early 1970s. Their romance, according to LF, was doomed by a variety of incompatibility. Bacon was a masochist, but Dyer was not a sadist.

'Francis met Dyer, who was a burglar, when George was in the act of breaking into his flat. Francis thought he was a thrilling, violent criminal. They went to bed immediately. But

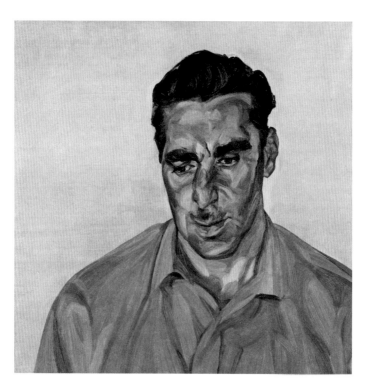

Man in a Blue Shirt, 1965

actually, it was a complete misunderstanding. George was not queer – though he was very odd. He was very fond of Francis, who would go out and get beaten up – which was what he enjoyed, of course – and come back with black eyes, covered in bruises. George would be upset and concerned, which was the last thing Francis would enjoy. George got very depressed, he came and stayed with me in Paddington for a while, and I painted him. In the end, of course, he killed himself.'

I suggest that while Francis Bacon liked an atmosphere of threat, LF likes one of risk. 'Well, yes,' he agrees with alacrity. 'I enjoy testing my luck and taking a chance.'

21 February 2004

At six I ring on LF's bell having woken and breakfasted in Arles, where I have been with my family for a few days exploring the places where Van Gogh worked and lived. Josephine is to drive down from Cambridge to join us and afterwards we shall go to the National Gallery with David Dawson to see the El Greco exhibition. I show LF a couple of exhibition catalogues I have bought in Arles; one of them includes a facsimile of the petition by Van Gogh's neighbours to have him locked up as a danger to the neighbourhood.

LF is very struck by a drawing of a man, a surrogate perhaps for Vincent himself, striding along the road to Tarascon, but then he says he has never seen anything by Van Gogh that wasn't marvellous. 'Even the very early things, from the time when he was just beginning, are wonderful. I've never seen a bad one.' This is all the more extraordinary since

Van Gogh worked at an astonishing rate – sometimes above a painting a day – especially in his last months at Auvers.

The pace at which a painting is executed is a personal matter. Artists all have their own tempo of work: some are lightning swift; some are slow. In November 1888 Van Gogh painted his first portrayal of Madame Ginoux, *L'Arlésienne*, in an hour, as he claimed in a letter to his brother Theo, later reducing the estimate to forty-five minutes. LF is at the other end of the spectrum of painting velocity. Routinely, he takes a hundred times as long as that to paint a picture, maybe more.

He tells an anecdote about Picasso. 'When I went to Paris in the forties, I used to go to his studio in the rue des Grands Augustins, on the corner, which was absolutely marvellous. He had two floors of a wonderful, palatial seventeenth-century building. Once when I was there, Picasso showed me some paintings and asked me to choose which I thought were the best ones. I selected four or five, and he said, 'I'm very pleased you've chosen those as they are among the ones I painted yesterday.'

'I really didn't know what to make of that. He did sometimes paint very fast, but afterwards I wondered why they weren't wet. Or perhaps, partly because I knew how to handle pictures, I was careful and didn't notice.'

On the other hand, Ingres – an artist whom LF reveres – took a decade, with pauses and intervals of despair, to complete his portrait of *Madame Moitessier* (1856, National Gallery, London). That is a record that even LF has not – yet – approached.

. . .

Titian, *Diana and Actaeon*, 1556–59

LF is hugely interested in the old masters, and hugely partial in his judgments of them (it takes a bold spirit to dismiss Raphael and Leonardo). Above all, he is mad about the two late Titians, *Diana and Actaeon* (1556–59; p. 123) and *Diana and Callisto* (1556–59), loaned for many years by the Duke of Sutherland to the National Gallery of Scotland [*Diana and Actaeon* was acquired for the Nation in 2009]. In 2001 he spoke to me at length about them for a newspaper series I was writing at the time, in which artists chose a great work of the past to talk about. What he said amounted to an account of what he values in painting, and hence what he is aiming at himself, above all by the way he began: 'These two Titians are intimate yet also grand.'

'About twenty years ago, when I was staying on the Scottish borders, I used to drive into Edinburgh almost every day to look at them. In the end, the guards seemed to be getting a little worried because I was taking such a close interest in them.'

'The National Gallery of Scotland also has a wonderful Rembrandt, *A Woman in Bed* (*c.* 1645), and normally I couldn't imagine not first going to see a picture such as that. But, in comparison, it seemed to have such a dim, almost dingy, bedroom atmosphere. And these Titians are so full of light, and air.'

'Since then they've been among my absolute favourites. I love many things about them. I like the way that, the more you look at them, the more dogs you seem to find. And the way the drapery flung over the branch to the right of *Diana and Callisto*, and the curtain to the left of *Diana and Actaeon*, were both obviously done at the last minute out of pure *joie de vivre*.'

'I can't say which I like the most, but I would love to have one hanging on my sitting-room wall, though I'm not sure it

would fit. Like all things that have affected me very much, after I'd seen them I couldn't remember how big they were.'

'How is it that these paintings, which are as effortless as Matisse, affect you more than any tragedy? Everything they contain is there for the viewer's pleasure. It hardly matters what is going on. The water, the dogs, the people, though they are involved with each other, are there to please us. To me, these are simply the most beautiful pictures in the world. Once you've seen them you want to see them again and again.'

...

During the sitting we talk a bit about El Greco, in advance of seeing the exhibition. He is, I suggest, one of those artists whose work appeals to you when you are young, then a little later you reject it as being too obvious, too easy. Later still, you realize that he was a great painter after all.

LF says that he very much liked El Greco when he was a teenager, and looked at photographs of his work. The *St Martin and the Beggar* (1597–99; National Gallery of Art, Washington, DC) was a particular favourite (it was with me, too, when I first began looking at art). I think there is some affinity between LF's youthful drawings, with their elongated faces, and El Greco (p. 126). But vastly as he loves certain pictures – those Titians for example – LF feels it is important not to look back with too much reverence. A painter must see all that has been produced up to now as merely an aid to his own work.

Talking of a friend who painted for years without ever showing the results in public, or even much in private, LF diagnoses his problem as 'excessive reverence for the art of the past, which would be, I imagine, completely crippling'.

Old Man, after El Greco's St Philip, 1940

LF's anarchic approach to existence assists him in avoiding that trap. He goes to an art gallery, he says, 'as you would go to a doctor, to go round thinking, Ah, that's how that could be mended. That's the way to put that right!' This attitude requires magnificent self-confidence: to regard the entire history of art up to date as an assistance to what one wants to do oneself is cheeky, to put it mildly. But such audacity is necessary for an artist who intends to add something new to a tradition already 5,000 years old.

...

After dinner, LF, David, Josephine and I go to the National Gallery to see the El Greco exhibition. LF is entitled to visit the museum after closing hours, a privilege awarded to some senior artists and trustees. Neil MacGregor, the former director, reports that he often met LF wandering around there in the evening, and learned a lot from him because he sees things as an artist. This is quite different from the angle of vision of an art historian.

It is a slightly eerie experience being almost alone in this place that is usually so packed. LF is struck by the great sense of reality of certain works – the *St Louis* from Paris, the boy with a lighted coal from Edinburgh, the wonderful portrait from Boston (but not its horrible frame). But over all, he is disappointed. He is particularly upset by the slick, glossy, over-cleaned, over-bright appearance of many of the works (including, sadly, *St Martin*). 'I have never seen so many completely fucked-up pictures. Sometimes I feel I could almost name the Winsor and Newton white the restorer has used.'

LF is highly conscious of a painting's physical constitu-
tion. He is already thinking, he says, about how his own
works will age through time, and wishes restorers would
allow 'old things to look old'. He was utterly infuriated, years
ago, by the effect of restoration on Piero di Cosimo's *Satyr
Mourning over a Nymph* (*c.* 1495), in the National Gallery,
which was previously a painting – with reclining nude,
tender mourning faun and attendant dogs – he loved.

Some of his disappointment, though, cannot be put down
to over-restoration. 'Look at that leg!' he exclaims in horror
in front of the *Crucifixion* (*c.* 1580) from the Louvre.

'The most important quality any painter can have', he
muses, 'is the strictest possible self-criticism.' That is the
reason why LF edits his own output so strictly, sometimes
putting his foot through pictures that don't come up to his
standard. He feels El Greco, who ran a busy workshop
turning out multiple versions of some pictures, let out too
many dodgy paintings. His reaction makes for a subdued
ending to the evening.

I am feeling tired, and so is LF, although he says that he is
experiencing periods of remarkable clarity and productiv-
ity while working, alternating with times when he feels very
rough. Making anything – a book, a painting, any long
project – is a physical and psychological effort. Energy is
expended, muscle-power used. When we look at an artist's
work – the seventy-odd years of Picasso's output, say,

or Titian's – we are encountering not merely a lot of pictures, but an index of their vitality and tenacity, the vigour with which they continued to move and think and care about what they saw, day after day, year after year.

There is an element of sheer endurance about these sittings. Sometimes in the last hour or so it feels a bit like the last stage of a long race or climb. LF and I are roped together, and I am willing him to keep going.

In a taxi last week, speeding down the Bayswater Road towards Locanda Locatelli, he turned to me and suddenly asked where a set of bathroom scales could be purchased. He had had the impression recently, it turned out, that he had put on a pound or two of weight (he is constitutionally light, and powered by nervous energy). 'When you work on your feet even an extra few ounces make a difference.' It sounds crazy, but he has a point: painting, his sort of painting particularly, demands stamina. I suggest John Lewis for the scales.

Energy is another requirement that LF husbands and monitors, and finds in surprising sources, such as cigars, which he would puff on occasionally in the past, remarking that 'they are very good for energy', though I haven't seen him with one for several years.

Mental stamina is required too. All long-term projects require this ability to keep going after the first excitement, through periods of despondency. But journalism, to which I am perhaps addicted, is more short term; it can be done on a rush of adrenaline, then on to the next thing. Maybe that's what's the matter with it. Watching LF paint my portrait is making me think about the way I work myself. It is an example, enacted before my eyes at every sitting, of measured, steady progress towards a final goal.

LF tells the story of Augustus John's son Caspar who in later life became Admiral Sir Caspar John and First Sea Lord. Someone once remarked to him on the contrast between his career in the Navy, and the rackety bohemian milieu of his father. 'To be a painter', answered Admiral John, 'requires enormous discipline.'

'I always thought', says LF, 'that an artist's was the hardest life of all.' Its rigour − not always apparent to an outside observer − is that an artist has to navigate forward into the unknown guided only by an internal sense of direction, keep up a set of standards which are imposed entirely from within, meanwhile maintaining faith that the task he or she has set him or herself is worth struggling constantly to achieve. This is all contrary to the notion of bohemian disorder.

. . .

As well as his physical fitness, LF is highly conscious of the mental confidence and resilience he calls 'morale'. It is one of the qualities he is strongly conscious of in other people. Describing a writer he once knew, and disliked, LF says, 'She is one of the few people I have met of whom I would use the expression, "rotten to the core". She did what the Bible describes as "bearing false witness", that is, systematically lying about other people's actions and motives. One thing about her was that she had very poor morale, thinking for example that one bad review could do one real damage. But being thoroughly nasty and constantly full of confidence and energy is pretty rare. That would almost count as evil, which is something one hardly ever encounters.'

His own morale, though − one would guess − generally good, is subject to fluctuations. All manner of factors, including

lack of punctuality in people coming to see him and banality in conversation, can cause it to flag.

For example, he had lunch with somebody who was perfectly nice. 'But – I don't know, maybe it's because I've got so old – certain remarks immediately get me down: "It must be wonderful to be creative"; "I've always wanted to be a painter but I never had the talent." I just start looking for the way out.'

The need to keep on steadily, throughout a long, long span of time, is built into LF's working method. His way of painting – and indeed his entire career – is an exercise in channelling energy, despite innumerable changes in mood and circumstances. In the past he has been able to do this although living in a way that might seem at first glance wild and rackety. 'In my way,' as he says, 'I'm very even.'

In a taxi a week or so before, I said that there were days when I found work just seemed to flow, on others writing was like trying to march through knee-deep porridge. He agreed that it was the same with painting, but – echoing his remark about the atmosphere of risk – that: 'With my temperament, if things seem to be going well I immediately want to test it, by being more audacious.'

...

On the other hand, he is also fiercely self-critical, and it was in that way that he felt El Greco had let himself down. Francis Bacon, by contrast, was perhaps over-stringent with his work. Or at least, it is said that in his early days he threw away paintings that afterwards he regretted losing (some of which reappeared after his death).

'Did Bacon destroy any pictures that were really good?'

'Well, perhaps not any of his very best things, but at that

time he was very fastidious and he certainly destroyed some which were better than any he did later. I remember a pope I saw in his studio that I'd certainly like to see again. Of course, anything that's gone says, in memory, "You destroyed me, and now you'll never see me again, and I was so marvellous."'

It is typical of the way LF thinks to give inanimate objects a voice in this way – in this case a plaintive one. Of course, here the vanished work is expressing LF's own worry. He destroys quite a lot of paintings and etchings, either when complete or abandoned. But his habit of leaving them around in the studio gives them some slight hope of a reprieve. Occasionally some unfinished fragment is rehabilitated, and suddenly appears in public view.

...

From the time that he was a small boy, it was always a known fact in LF's family that he was going to be a painter. But he was susceptible to different currents of feelings on the matter from his parents, Ernst and Lucie. Anyone saying you must do something, he notes, is very off-putting, so in a way he welcomed a little parental discouragement. When LF committed an adolescent misdemeanour at the age of sixteen, during his first year at the Central School of Art, his father said, 'You don't deserve to be an artist!'

He recalls another such occasion: 'My father and I were at a sale where there were some Rodin drawings which he rather liked. I said, "Why don't you buy one?" He replied, "I don't think I'd like to have anything as good as that." As I wanted to be a painter, I found that rather disappointing. But since my mother was so keen on my becoming an artist that it made me

feel sick, it was a good thing in a way that my father was against it. If they'd both been in favour, I'd have had to become a jockey, which was my other idea for a career.'

...

The finding of the chalk marks, which we made to fix the position of my chair on the very first evening, is part of the ritual at the beginning of each session. They are now becoming so faint that they merge into the scuffs and abrasions that cover the boards, but LF almost always seems to find them. If he doesn't, then we are immediately aware of a change in our accustomed relationship. Small modifications of view and angle make a big difference when it comes to painting. Sitting makes one hyper-aware of such nuances. This is part of the explanation for the extensions that LF sometimes has added to his canvases halfway through the process. During the growth of the picture some constraint has become apparent. He feels a need to put more space around a foot, say, that is awkwardly jammed against the edge.

LF is trying very hard to finish the big picture of David lying naked on a bed with his dog, Eli, which he has been working on in his other studio in Holland Park. He wants to include it in an exhibition he is holding at the Wallace Collection – now only a month away. We had discussed the possibility that this picture of me would be ready in time for the exhibition. But LF is more concerned about finishing the big nude and dog, now that he has thought about the matter.

'This picture of you would enrich the exhibition, but it would not open another window on it as the other one would.'

Perhaps that's because the other is a picture of that favourite theme of his, two creatures – one animal, one human – together. Pairs of lovers are another similar genre in his work. Depicting couples, whether human/human or human/animal, is a way of exploring a range of feeling untapped in his paintings of single figures. This comes out in what he has to say about a visit, long ago, to the Toulouse-Lautrec museum in Albi.

'It was very interesting, very exciting. That marvellous subject of the whores sitting round a circular pouf, when you look at it you realize that the one thing he couldn't do was people together. To me, the most touching Lautrec in the museum is the one of the two girls, both whores, in a bed; you just see their heads. It's so moving. They've finally finished their work and there they are, because they actually like each other.'

Many of LF's own pictorial duets are poignant in just the way he describes.

...

I feel slightly hurt and disappointed by the decision to give the other picture priority, which is plainly a sign that I am beginning to invest a good deal of *amour-propre* in the still only half-finished arrangement of beige, khaki, pink and grey on the canvas. The picture is gaining some of my own sense of self. I want it to succeed. Of course, the Dorian Gray possibility also exists: that it will come to reveal secrets – ageing, ugliness, faults – that I imagine, rightly or wrongly, I am hiding from the world.

For instance, I have not had a haircut since the sittings began – partly because I have been busy, partly because I feel inhibited about tampering with my appearance – but now it's

getting ridiculously long. LF asked last time whether I could have about two weeks' worth taken off.

He spends a lot of time on my hair during this sitting. Obviously it's going to be a feature of the picture. In particular, I find myself feeling secretly slightly anxious about the hair in my ears – usually removed with a deft sweep of the electric clippers by the barber. Now it is protruding in the manner of the late Leonid Brezhnev or Lord Goodman (the latter another of LF's sitters). If he spots it and decides to include it, it's there for all time. But on the other hand, I can scarcely ask him not to.

This is part of what he meant perhaps about the unspoken contract between sitter and painter, and how he would want to contravene it if it existed. In the case of a sitter for Thomas Gainsborough or Rembrandt, there was in reality a reciprocal agreement. One of Rembrandt's clients made a fuss because he didn't like the way his daughter looked in her portrait. With LF – as with Alberto Giacometti, Bacon or Van Gogh – there is no such understanding, and no grounds for appeal.

27 February 2004

This time I have had a haircut. I asked my barber to do exactly what LF had asked for: to take off two weeks of growth. Previously the top of my ear was in shadow, now it has appeared. I begin to understand the difficulties of making a fixed image of a person who is constantly, if only slightly, changing in such ways.

A Dorian Gray-type revelation, quite unexpectedly, has emerged from the painting – or at least the painting process – this evening. It popped up in the conversation: that I personally am especially liable to change.

'You look different every day.'

'More than most people?'

'More than almost anyone I've ever encountered. The features don't change, it's more the way that they are worn.' This, I suggest, must be to do with the fluctuation of my moods. 'Well, that's what I assumed.'

This is rather startling. Throughout all the sittings to date I have thought of myself as a fairly unchanging object that LF is slowly tracking around, taking a long series of sightings as a surveyor might. Now it suddenly seems more like mapping a cloud, wave, or similar object in constant flux.

What LF has observed suggests strong mood swings, which I suppose at least sometimes I experience (though I imagined they were not obvious to other people). Josephine concurs that indeed I seem to alter in appearance from day to day.

...

At the end of the session I ask LF whether it would be possible to paint the background – which is a misnomer as far as he is concerned, since he prefers to call it 'the ground' – without my being there. 'No, for me, it's absolutely about what your head is doing to that screen.' I am sitting in front of the battered, blackish surface of the screen – which comes close to visual nothingness. So to an extent around me he's painting air. In fact, he has done a good deal of background – or rather, ground – this time. 'It helps me to understand your head, and also another ear.'

The idea the sitter has to be there while the painter fills in empty space around them might seem crazy, but it has a considerable amount of pedigree in the history of art. The late nineteenth-century Italian sculptor Medardo Rosso, for example – an artist very different from LF – thought exactly the same. 'In nature', he wrote to a friend, 'there are no limits, and there cannot be in a work of art. It should capture the atmosphere that surrounds the figures, the colour that animates it … When I do a portrait I cannot limit myself to the lines of the head since this head belongs to a body and exists in an environment that influences it: it is part of a whole that I cannot suppress.'

This seems to be LF's view. 'I like the models to be around in the studio even when I am painting something else. They seem to change the atmosphere, in the same way that saints do, by their presence.'

The painting of emptiness presents its own challenges. LF, long ago, travelled to the town of Castres in southwestern France specifically to see the great picture by Goya, *The Junta of the Philippines* (*c.* 1815; Musée Goya) that has for some reason ended up there. This is the largest painting the artist ever executed, and of a subject that was on the face of it fantastically dull: the annual meeting of a trading company the business of which had become completely unprofitable as a result of the Napoleonic Wars. So in a way it is an image of futility. It depicts various notables and shareholders looking very bored, and the King of Spain. Above all, it is a painting of the empty space in an enormous room, which seems both mysterious and somehow very Spanish.

'I went to see it and it is really of absolutely nothing. I actually did a cultural trip, it was some way away from where

Pluto's Grave (work in progress), 2003

I was – sixty miles or so – but I thought I must go and see it. It's an extraordinary place, Castres. When you arrive you think, there can't be a picture here. This was long ago but I don't think it can have changed.'

A year ago, he painted a picture of his own of almost as little. It depicts the patch of his back garden where his old dog Pluto is buried (pp. 138, 140). Like the Goya, it has some recognizable items in it – a few leaves, the little wooden grave marker that David Dawson painted Pluto's name on – but the rest is mainly space.

'I was rather excited by that painting because it's almost of absolutely nothing, so how the actual paint went down has just never been as important. By nothing, I mean there's not an eye, a nose or a mouth, in fact it's mainly of dead leaves. Since they couldn't be painted one by one, otherwise it wouldn't work at all, it's oddly related and seems of nothing at all. It *is* very like the garden on the other hand.'

...

The picture continues to edge or inch forward, but for several sittings there has been little dramatic progress. By now almost all my chin has appeared. Just before we go off to Sally Clarke's restaurant for supper, LF says that we have finished, then changes his mind and decides to fill in a tiny spot of white canvas, less than the size of a bee, below my chin. He says that if he leaves it, it will annoy him.

'I am getting close to the blue, but there is quite a lot down here' – he indicates the next area and some ground – 'that I'd like to do first.'

Pluto's Grave, 2003

3 March 2004

I arrive and LF offers me a glass of claret, Château Cheval Blanc '83, a St-Emilion. 'A marvellous name, White Horse, for a red wine, isn't it?' It is characteristic of him to favour a vintage claret for its horsey associations. It puts me in a mood of mellow relaxation for the sitting.

We discuss the question of finishing. 'Finishing well in a picture is of course the most important thing of all.' I say that in the case of a book the end is the least important because by that point the reader has absorbed almost everything the author has to say. Many great books, almost all of Dickens's novels for example, end disappointingly. 'Kafka', LF points out, 'ends enormously well. The ending of *Metamorphosis* is marvellous, don't you think?'

Finishing a picture, of course, is a different matter from finishing a book, because it is not read page by page over a period of time, but seen altogether and at once. The way the painter leaves it – finishes – is what the spectator sees, first and always.

Telling whether a picture is finished has become a much more ticklish matter than it is when, say, painting a door or making a chair because there is no agreed standard of what counts as a completion. At one point, 'finished' meant 'smoothly detailed', and painters such as Constable and Gainsborough were criticized in their lifetimes for exhibiting 'unfinished' works. Now, however, finished means something like 'complete as a work of art according to its own internal laws', and that is a much more difficult matter to judge. LF's own criterion, 'I begin to think a picture is finished when I have the sensation I am painting someone else's picture', is elusive, though one can see what he means.

I ask if he is pleased or sorry when a picture is finished, since for him, too, it must constitute an era in his life. 'I don't think I have either response. I'm more worried in case it isn't really finished.'

In practice, he often hesitates before deciding that he is actually done with a picture. Its finishing will be announced, but then postponed, maybe for weeks. The moment to stop may seem close, but then recede. Last year, LF phoned me up and described how exactly that had happened with the picture of Pluto's grave (p. 140).

'I finished my picture only today. It went on and on and on. I was very pleased with it, but then I thought it could be made better and as a result it got worse. Then I went on a lot and now I think it's much better than before.'

But the picture of me is a long way even from the point when he might start to wonder whether it's finished. That is still 'some way off'. This evening, he concludes, 'I've got on very well in an all-over sort of way.' He points out places where he has added or strengthened – on the brow, beneath the mouth. And at the end of the sitting, a shadow has appeared below my chin. 'I keep seeing new possibilities and ways of making the features more animated.' The mutability of my appearance, which he revealed last time, makes it more difficult for him in a way, but he is trying to find ways to use it.

I ask him whether my portrait was linked to the one of David Hockney, since they are similar in format and angle of vision (p. 144). That is on display in the National Portrait Gallery at present, along with a selection of David Dawson's photographs (p. 143). 'No, the picture of you has always been linked in my head with the one of the back end of the skewbald mare, which was finished about the time it started. I've learned

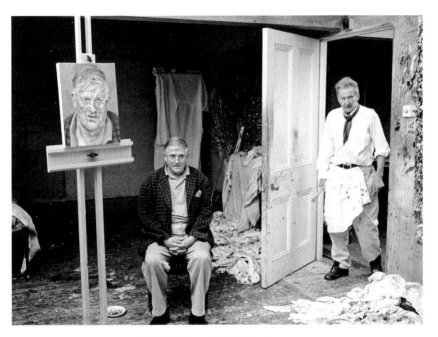

David Hockney and Lucian Freud, 2003

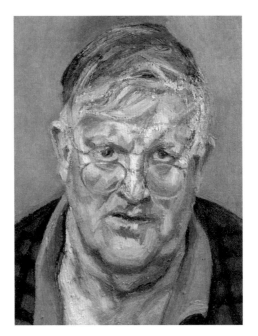

David Hockney, 2003

a lot from that about painting more freely, and I am trying to apply those lessons.' Of course, there is nothing discreditable, from the sitter's point of view, in having one's portrait aesthetically linked with a horse's hindquarters – which is, after all, a noble object. At least, I suppose so.

There is constant cross-pollination between LF's pictures; he also says that he is trying to use things in the picture of me that he has discovered from the tiny self portrait he has been working on. This is now suddenly almost finished. He has added at the last minute a hand that the head is resting on, as in a Jacobean tomb. 'I had to remember how it went, because it was my painting arm.'

...

Even in the short-term, painting is always a matter of memory. LF looks very closely at me, making a measuring gesture, then he turns to the canvas and puts in a mark – or, just as possibly, stops at the last moment, reconsiders and observes again. Sometimes he wipes out what he has done with a piece of cotton wool or cloth. There is an interval, however short, between the observation and the act of painting, then another pause for consideration.

During that time, the original sight has been passed through LF's eyes, nervous system and mind, then he has contemplated in relation to all the other notations he has made. This process is repeated hundreds, indeed thousands, of times. Thus a painted image, certainly one by LF, is different in nature from an instantaneous image such as a photograph. David Hockney puts it like this: the painting of him by LF has over a hundred hours 'layered into it', and with them innumerable visual sensations and thoughts.

...

The experience of sitting is of being a completely passive subject – or rather object – not moving, often not speaking, just looking, while you are observed with the closest scrutiny. Nonetheless, LF says, 'I have the impression that you are helping me very much.'

Indeed, I continue to be closely interested in the process, and consequently alert, seldom drifting off into boredom. On the other hand, my temperamental impatience is present beneath the surface. I want the picture to move on, I want it to be finished. My hope is that he will begin a new area – the chin, the scarf, the jacket. The truth is, though, that I have no idea how much more there is to go, or what will constitute 'finishing'.

LF doesn't seem remotely concerned about hurrying. Over supper he says, discouragingly, that the picture still has a good way to go. Then, he adds, he doesn't really know either. He has decided to push on with the picture of David Dawson and Eli the dog, so he doesn't want to do a sitting on Friday. This is a relief; the title of one his grandfather's books sometimes pops into my mind: *Analysis Terminable and Interminable*. There is risk of sittings with LF becoming interminable. But simultaneously, the decision is disappointing.

9 March 2004

Invited to lunch with LF at Sally Clarke's. We have decided not to resume sittings until after LF has finished his picture

of David and Eli. Over soup and grilled mushrooms (and halibut for me), he says that in that great contest of twentieth-century art between Picasso and Matisse, he has decided that Matisse was in the end by far the greater. This was because Matisse is essentially, in his view, concerned with 'the life of forms – which is what art is about, really'. Whereas, Picasso – much as LF admires and enjoys his work – was out to 'amaze, surprise and astonish'.

And pictures that try to amaze and astonish the viewer are one of his aversions. Picasso, he thinks, was not only guilty of that, but also of the other offence he mentions: emotional dishonesty. 'I have never thought that the Blue Period had anything of great quality. The pictures are absolutely full of false feeling.' Once again, for him quality in art is inextricably bound up with emotional honesty and truthfulness.

When he talks about Picasso, whom he knew a bit, it is clear how for him the psychological quirks and even the physique of the artist are bound up with his work.

'Picasso behaved like a marvellous conjurer. When you left his apartment, you instinctively looked back up at the windows, high above. He was aware of that reflex, because one day when we glanced up like that he was at the window, making bird shapes in shadow against the blind with his hands.'

'He asked me once whether I wanted a cigarette, and he leaned across to a big marble stand in the hall, not an unusual thing to find in a Parisian flat. There was an elaborately beaten African metal gong on it, which he lifted up with a flourish and there underneath was a packet of cigarettes.'

'When I took Caroline there he painted her fingernails – which were tiny, in any case, because she bit them – with little

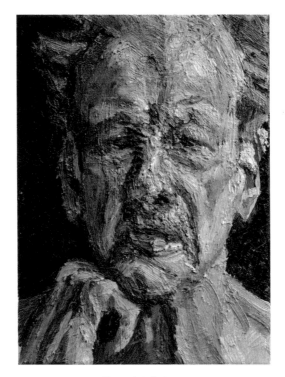

Self Portrait, Reflection, 2004

faces and sun shapes. She kept them for as long as possible, but eventually they disappeared. She was in the flat alone with him for about half an hour. When I asked afterwards what had happened, she said: "I can never, ever tell you." So I never, ever asked.'

'Picasso was a very small man, but finely proportioned so that he looked good. He was no more than 5 feet or 5' 1". I remember him talking about London, where he stayed after the First World War, in 1919. He complained that in London the men's trousers are up to here, and he gestured at his chin level, and they might have been, just about. I was aware of how much his attitude to life was affected by his being so small. He would mention, for example, when talking about women, how big they were.'

In fact, this does illuminate aspects of Picasso's art: the looming female nudes, for example, and naked giantesses – massive and desirable.

'He was very malevolent, absolutely poisonous, not that I minded it much. I asked him once what he liked about a friend we had in common. He replied: "That I can make her cry whenever I want to."' The sadism brings to mind the picture of Dora Maar weeping, in the Tate, a marvellous picture that in 1942 LF looked at during a long train ride to Brighton, where he was transporting it to an exhibition, marvelling all the way at its strength, undiminished by the bright light of the sun.

...

After lunch we go back to the studio and he shows me the tiny self portrait that he has now completed (p. 148).

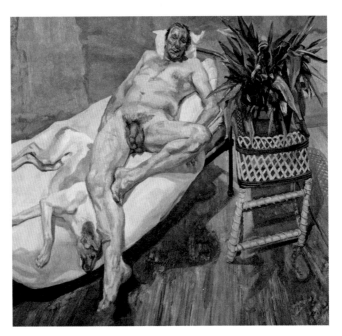

David and Eli, 2003–04

We recommence. In the interim, I have been to Naples on holiday, and LF has finished the *David and Eli* painting (p. 150) with a tremendous burst of concentration, completing it at five o'clock in the morning just before the exhibition at the Wallace Collection was going to be hung. Now, the exhibition is open and he is taking it slightly easier, though that lack of pressure in itself is a source of concern.

When we start the sitting, he says: 'It's a relief to be painting this again. When I finished David and the dog on the bed, I felt that all sorts of paintings that I'd started at different times had all finished together, which sometimes happens. I thought, perhaps I'm just being allowed to finish those, and that's all. So I have been running around trying to start other things.'

LF's life and work are so closely connected he worries, superstitiously, that if one ceases so will the other. There is very little in his days that is not connected with his pictures. Even when he is resting in the afternoons – generally between the ending of the afternoon sitting around four and the arrival of the evening model after six – he is thinking, he says, about forms and paint and how they might work.

...

LF very seldom travels, these days at least. 'Perhaps I don't really want to go anywhere else because, having arrived here at the age of ten, I still feel like a visitor in the most exciting, romantic place I can imagine. Whenever I think of going somewhere else, I think it's mad when there are parts of *London* I haven't ever visited.' But his disinclination to move

from the place he lives also arises from the fact that this is where his work is. In his Harun al-Rashid mood, he feels London is his town, full of potential subjects.

When young, he says, he felt permitted to take breaks, think-ing 'with *my* energy I'll easily catch up'. But the older he gets, the more pressing the need to get on. 'I've always wanted to work, but when I was younger I felt I didn't want to be a machine. But' – gloomily – 'now perhaps I shall have to become one.'

Then, after a pause: 'Have I ever told you about my appearance as a film extra? I suppose that was the closest I ever got to doing a proper day's work.' It's an arresting question, so of course I say, carry on, please do.

'I performed in a couple of films, one with George Formby called *Much Too Shy*, I think, in 1942. There was a scene at an art school where George Formby was supposed to be chasing the model, who was naked – or what passed for naked in those days – wearing a bra and knickers or something.'

'I was supposed to be painting at an easel. The director came up to me and said, "You don't know anything about how to paint, do you? Look, I'll show you." And he took the brushes and palette. Because I am left-handed I was holding them the other way round. He demonstrated [LF makes a dramatic gesture of throwing back his head, staring dramatically and then painting with a flourish] and said: "That's how you do it!" It was very funny.'

. . .

The portrait, when I look at it during a break, seems to have a twin expression. There is the half smile, but also a slightly anxious feeling that seems to coexist with the smile. He comments: 'The advantage of taking so long is that it allows

me to include more than one mood, though goodness knows I
don't always succeed. Sometimes, the smile is there. Today, you
looked very nervous.'

...

Over dinner, we talk about the French photographer Jacques
Henri Lartigue, whose son Dany I'd just travelled to the
South of France to interview. 'I think he was marvellous.
No one else could photograph pleasure the way he could.
I remember saying that to Francis Bacon one day, that
Lartigue could capture the essence of happiness, and Francis
replied: "The essence of silliness more like."' LF hugs himself
with amusement at the memory of this exchange.

Joie de vivre is not a quality that many people would asso-
ciate with LF – still less with Francis Bacon – on the basis of
their art. But, by repute Bacon had it in person, and LF's
company is tonic because of the verve of his approach to life
and the observant wit he focuses upon it. Actually, that does
come through in his early drawings, and is still present even
today, though often deeply hidden.

He mused recently on a piece by a critic who praised his
work but said his paintings are terribly sad. 'But I don't think
any really good pictures are sad. Sad is "Oh dear, oh dear,
what a shame!" It's a lowering feeling. Good pictures, on the
other hand, are too vigorous and make you think of too many
different things for that.'

...

Despite the fact that he is over eighty, and has harnessed
himself to a routine of perpetual work, LF's approach to life

is essentially youthful. He relates a conversation he had a few years ago with a sitter.

'I told him about my life and the things I was doing, and he said, "You behave like a teenager!" But age is just a trick of time, it's not a *styling*. I suppose I do not set any limitations on my behaviour. I follow my feelings. To him I replied, "I know that you are married and so forth, but surely on occasion you feel attracted to other women. How do you feel then?" "I feel like a roué." I thought that was terribly good.'

At the very first sitting after we resumed, LF said, 'The blue scarf is a challenge for me, to harmonize it with the other colours.' Today it finally went in: two strands of blue. It's a surprise to see it on the palette after all these months of fawns, greys and beiges.

Looking at the picture on my own during a break can make me feel Dorian Gray-like, in reverse. That is, the picture sometimes looks a good deal more vigorous and vital than I actually feel myself. When LF returns, I tell him this. 'I am not surprised that you should occasionally feel like that, since your spirits and morale seem to vary very much, although you are always alert.'

. . .

We talk about the Gwen and Augustus John exhibition that is coming to the Tate in the autumn. LF knew Augustus John quite well at one point, when John was old and he was very young.

'I went to visit him at his house in France, where from time to time he would go out to his studio in the garden. Then you would hear' – LF makes inarticulate cries and roars of rage, and a voice like a veteran Shakespearean actor such as Donald Wolfit exclaiming 'Oh my God!' – 'And when you saw the pictures, you could see why. He had got out of the way of working.'

So there was a warning, when LF had just begun his life as an artist, against ceasing to work. LF, older now than John was then, carries on unremittingly. He was appreciative of Augustus John more as a figure – he would have been a good subject for LF – than as a painter.

'He had a marvellous sense of style in the way he dressed and his air. I remember walking back to his studio in Tite Street, after having had lunch, when it started to rain. Ducking into a doorway, he said, "Shall we shelter from the drops?" I thought that was a phrase from another age.'

'I drove him up to London from the country, and Dodo [Dorelia], his wife – who was absolutely wonderful I thought – gave me some advice. "He's a bit of a drinker, you know, so you might have to stop at a pub from time to time along the way." John certainly liked a drink but I never saw him drunk. At the first pub, the barman said, "Now, would your father like another?", and he was absolutely furious about that. Then, when I suggested another drink, "You don't have to stop at every bloody pub, you know!"' He would get extremely angry very quickly, then, just as quickly, it would be over.

For Gwen John, his sister, on the other hand, LF has the highest regard. 'I thought she was that very rare thing, a great painter.' LF's own work is far closer to the quietness, and fastidious rightness, of her work – its air of inner concentration – than it is to the flashiness of Augustus John.

He throws out a startling suggestion about the two of them. 'I think it is obvious from the letters, and from the way that Gwen John talked about him, that his first affair was with her. There is such a sudden change from his being terrified of women to being completely confident. It just makes you think of incest.' Whether true or not, and I don't imagine any direct evidence survives, this is a good example of how hard LF thinks about people, and the surprising conclusions to which he may come.

I say at the end of the session, 'I can imagine this picture finished now.' LF responds, 'Oh, can you? I can't.'

16 April 2004

I arrive with my fourteen-year-old daughter, Cecily, and ring unavailingly on the doorbell. LF arrives after a few minutes looking somehow as if an electric current had been passed through his hair. 'How are you?' 'I'm feeling rather crazy, as I've just come from my cranial osteopath.' Cecily settles down to do her homework at his dining table, while LF and I go upstairs for the sitting.

There is a new night nude that has begun, the model being someone who works for the art moving and storage firm, Momart – which is how she came to meet LF. She is called Verity Brown and is posing on the evenings that I am not. The picture has started, as LF's nudes are inclined to, with her face, which has appeared on a large canvas otherwise blank except for a spare charcoal drawing. This is what he calls the 'getting acquainted' phase. LF explains: 'As a portrait painter, in a way

I was a frustrated painter of the nude. Afterwards, I used to treat the head as if it were another limb. When I began to work from Leigh Bowery (p. 158), I painted his head first as a way of getting to know him, then, and on several occasions afterwards, I found myself repainting the head after completing the rest of the picture.' That is, when he really knows the sitter.

...

Afterwards, we all go out to supper. LF finds a line of conversation that is adapted to interest both Cecily and me. He recalls his trip by boat to a Greek island in 1947: 'There were four classes, and also *nul couchette* and *nul pain*, which was how I went. It was only for three days; the men on the boat gave me some food. The Greek word for stranger is the same as the word for guest – that is very sophisticated, don't you think? They were always offering me things. "Take this sheep!" But it was quite awkward since I was living in one room. There was nowhere to keep a live sheep.'

LF is a wonderful painter of children and young people. He achieves this by taking them entirely seriously as individuals. Indeed, he is just as fascinated by his youthful sitters as by any of the others. For example, here is a characterization of a small girl who was sitting to him a while ago:

'She's rather interesting and rather odd. Do you know that sort of person who never stops talking and you can't stop listening to them. Do you know what I mean? They just go on and on, and they know what they are talking about. Good things come up and also reasonable things, and you realize that her conversation is non-stop thought that she's relating. Even when she tells her dreams, they are so

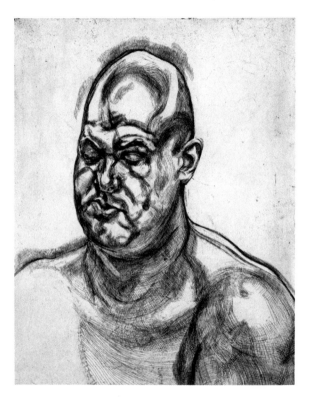

Large Head, 1993

complicated with so many people in doing so many different things that you think she couldn't possibly have dreamt that. Then you realize, yes, she must have done, because she's very accurate in her way and quite subtle and quite fastidious, there's no exaggeration.'

It is time to tackle the blue scarf, it seems, but something goes wrong. LF makes repeated efforts, three or four times, to mix royal blues on the palette. Always, however, something seems to go awry when he comes to put a touch on the canvas, the brush never quite makes contact or he applies a stroke or two then stands back, cocking his head and muttering. 'No, that's not it, definitely not.' He produces a bit of tissue from his pocket and wipes it off, then the whole process begins again with a close examination of the scarf itself, LF peering at my lower neck and chest.

'I had several attempts at the blue of the scarf and couldn't get near it. I started thinking, Is it a different colour? Finally I realized that it's me that's different. So I decided to do something else, and that was all right.' He had settled down eventually to doing some of the background – ground, that is – mixing a series of dark, greenish greys and steadily applying them.

While we are taking a break I compare the two strands of blue that LF put in last time as a sort of marker, I felt, or declaration of intent, for the actual scarf. It is distinctly darker, but then – I tell myself – this is a picture.

Armchair by the Fireplace, 1997

When I get home, I mention this difficulty with the scarf colour to Josephine, who replies, 'Which one were you wearing?'

Apparently, I have two royal blue scarves – a fact that was news to me. When we get them out and examine them, I see what I had never noticed – that one of them is about half a tone darker than the other, although the discrepancy is slight. Obviously, for the last sitting I had been wearing the lighter one, which LF wasn't used to seeing.

This accidental experiment seems to prove the extreme precision of his sense of tone and colour, and the degree to which the whole picture is a carefully judged harmony. LF noticed this difference, though he couldn't explain it, just as some conductors are able to register one off-key woodwind from an entire orchestra. I decide not to mention this mix-up for the time being.

...

LF has a mysterious visitor coming at seven. The doorbell rings, indicating he has arrived, accompanied apparently by Andrew Parker Bowles. 'Oh, David will let them in and come up. I want to make a point about the fact that I'm working.' Who could it be that is allowed to disrupt a sitting, even after the point has been made? And who could be accompanied by Parker Bowles? Someone royal, perhaps, but I never discover who.

David comes up and chats with me, accompanied by the dog Eli and Andrew Parker Bowles. We swap experiences of sitting. I say that the other chair (p. 160), which he posed in, looks more comfortable than mine.

'Oh, that thing! The trouble with it is that you fall asleep. I'd drop off and my stomach would drop out.'

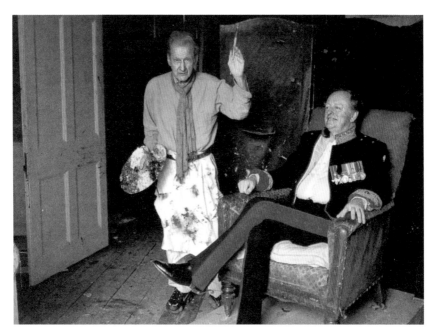

Lucian Freud and Andrew Parker Bowles, 2003

He turns to David: 'I was just saying to Lucian that my stomach didn't look like that, when you came along and took your photograph [p. 162], proving that in fact it looked exactly the way it did in the picture [p. 165].'

He politely compliments my portrait. 'Oh, that's very good! That's terrific!' And advises: 'I'd try not to let him change it too much if I were you.' That of course is an in-joke which we all smile at, an impossible idea. 'What's magical about it is that you've got a half-smile.'

I suggest to Andrew Parker Bowles that perhaps the smile was there at the moment the mouth went in. 'Three weeks before, more like.'

Absurdly, I feel flattered by his praise of my picture, and moved say something nice about his (which is indeed magnificent). One thinks of the picture as an extension of oneself, which to some limited extent it is.

Still, being painted this way has its drawbacks. 'Never again!' says Parker Bowles of his nearly two-year stint. 'A nice head and shoulders like this is much better.' We compare lengths of sittings. I remark that at one point LF decided to shrink my head. 'It's when he starts adding bits that you've got to watch out.'

27 April 2004

I arrive at the beginning of a violent downpour, ringing the doorbell repeatedly, and am just about to take shelter when LF comes out apologising for being so deaf. The rain brings a chill to the air, which is welcome since it has been so

warm and sunny up to now and I am wearing what is essen-
tially a winter posing uniform: tweed jacket, corduroy
trousers. We begin late, talking over a glass of claret for me
and a cup of green tea for him.

There is more delay while we try to set up the easel, LF
initially trying to knock the nut the wrong way – tighter – with
a hammer. After starting work, LF pauses to tighten the
canvas, which he thinks is sagging because of the dampness of
the evening, by tapping in chocks in the corners, again with a
hammer. 'I like it to be very firm because if my brush pushes the
canvas in, I feel it spoils my sense that I'm painting something
real. I think, Oh no! I'm only painting a picture. I once saw
Bill Coldstream at work and was surprised to see that there
were great sags at the sides of the canvas he was working on.'

Evidently, painting is a physical activity like playing the
piano or violin. Touch comes into it, and personal tastes in
questions such as the tightness of the canvas, its texture, the
variety of brush, and so forth. Of course, the result being
aimed at also affects all these choices. The transformation of
LF's style in the 1950s, from fine to broad, was manifested in
an alteration of brush: previously he had used sable, afterwards
hog-hair. Gowing described the difference: paint is 'driven
across the surface with the springy bristles of a hog-hair brush
quite unlike the touch of the pliant sable, which had followed
the forms with obedient literalness.'

...

This evening there is much activity, lengthy examinations
looking from the canvas to me, and then back again. LF
searches for suitable brushes among the quantities that lie about

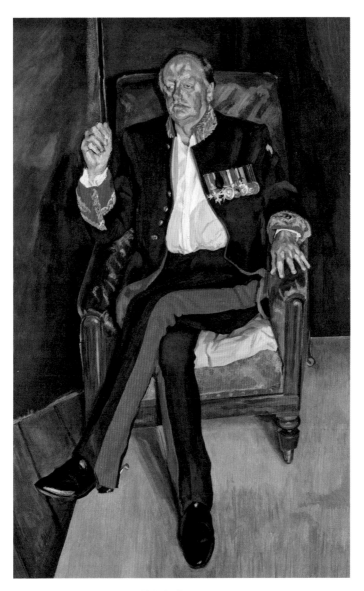

The Brigadier, 2003–04

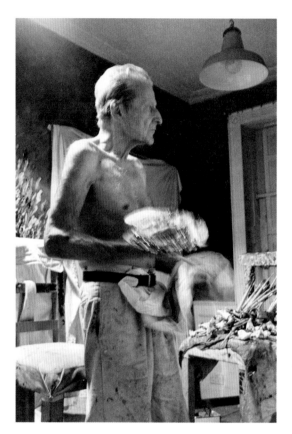

Lucian Freud, 2005

on top of the mounds of paint tubes, like the quills of a gigantic bird (which in some ways he resembles). In the end, little has obviously changed except for a large red-brown shadow that has appeared on the left-hand side. But altogether, according to LF, 'things are getting more specific'. And there does seem to be a slow process of coming into focus going on.

Sitting is a pleasure, an ordeal, and also a worry. At present, thank God, he seems pleased with the portrait. I say that it looks pretty strong to me, and he seems to agree, though not quite saying that. 'I am aware that I haven't yet brought out the way the muscles work just here' – he indicates the area to the right of my mouth. 'That's a bit weak. But when I think that, it probably means that the rest is okay.'

...

There is, in fact, a complex cat's cradle of muscles around the human mouth, among them the orbicularis oris, which enables us, among other useful actions, to kiss. There is also the risorius, which pulls the mouth horizontally, and the depressor anguli oris, pulling down on the corners of the mouth. In all, as I have learned from *The Face*, there are twenty-two muscles on each side of the human face, more than any other animal possesses.

These muscles are the same as any other in the body – bearing out LF's feeling that he could treat the head 'like a limb' – and at the same time different. As McNeill explains: 'Like most muscles, they anchor in bone. Unlike most, they attach to the skin. They make facial skin mobile, completely unlike the skin on the back or leg, so it shapes itself quickly to pulses from the brain.'

The result is a play of expression unique to *Homo sapiens*, and bewildering in its variety. Estimates of the total range of possible expressions – almost all with some emotional meaning – vary wildly, but are all impressively large. McNeill reports that one study of psychiatric patients suggested a total of 6,000, another conducted by a Dutch artist, by electrical stimulation of the facial muscles, discovered 4,096 in half an hour. Another study guesses at 10,000.

To imply something of this extraordinary fluidity is the challenge and part of the fascination of portrait painting. The selection should, moreover, be characteristic of the sitter. The eighteenth-century actor David Garrick could apparently run through nine emotions: joy, tranquillity, surprise, astonishment, sadness, despondency, fear, horror, despair, and back to joy. But this ease of expressive mimicry made Garrick, and the contemporary thespian Samuel Foote, unsuitable subjects for portraiture. Or at least, Gainsborough complained: 'Rot them for a couple of rogues. They have everyone's face but their own.'

Although the range of LF's sitters is vast, there are few, if any, pictures of actors. The closest he has come is fashion models.

...

Muscles, facial or otherwise, are a subject of endless interest to LF, being part of that 'world of forms' of which art, he says, consists. This comes out in his remarks about Michelangelo. When I mention him, LF replies: 'As a painter, I immediately think of those wonderful stomach muscles. You could look at them for hours. But I'm thinking more of the drawings and the sculpture. When I went to the Sistine Chapel I expected it to

be overwhelming. In fact, I found the most beautiful decoration I had ever seen above my head. But, though I've never been close to the surface of the ceiling, I shouldn't think that just as painting it was very interesting.'

It is hard to imagine a fresco of any kind – essentially a flat, rapidly executed medium – intriguing him very much in comparison with the complexity of gouts, smears, scrumbles, dabs and dribbles that oil painting, his kind of oil painting, allows. That subtle density of surface can parallel the elaborate skein of elastic muscles, bone and skin of which the face is made up.

Not surprisingly, the baroque setting of Michelangelo's early masterpiece, the *Pietà* (1499) in St Peter's, wasn't to LF's taste. Gilt and marble would hardly appeal to a sensibility that favours bare boards and girls without make-up. But conversely, the sculpture of the naked, dead Christ cradled by the Madonna was: two people, together, again. 'The church itself is like the most expensive junk shop in the world, with that horrible smell of incense. But in the middle of all that there was this beautiful thing, full of feeling.'

Jake Auerbach and William Feaver have made a film about LF's models, which is going to be shown on television, and before that at a special screening in the auditorium at the National Gallery. It consists of interviews with numerous sitters, including Andrew Parker Bowles, David Dawson, David Hockney and many others. The project has been causing LF mild trepidation for a while. He decides to attend

the screening, where many sitters and fellow artists have gathered, wearing an old and battered panama hat (an extremely ineffective disguise).

The film makes him uneasy, because although he appears only for a second at the end, wandering accidentally into shot – at which point a cheer went up at the National Gallery – the main topic of discussion throughout is naturally him.

'It is about exactly the least interesting subject in the world for me, which is myself. I'm egotistical, like most people in that I like to get my own way, but I'm not in the least introspective. Some of the people in the film were lively, some were boring. In the end, like everything, it's just one side of things.'

It is not quite true to say that LF is not introspective. Indeed, he is very perceptive about himself. It is more that the notion of others looking at him is the exact reverse of what he is always aiming to do: observe the subject. He is also always trying to keep his own emotions out of the picture, consciously at least, and warns against the dangerous illusion, for a painter, of thinking that 'anything by you is good because it is filled with your feelings'.

In the film, many of the former sitters talk about precisely what often interests me: their own experience of posing. As we chat in the taxi going back to the studio, it becomes apparent that naturally enough, his interest – at least retrospectively – is much more on how well the painting that they were posing for finally turned out.

...

Only the shirt and jacket remain untouched. I ask LF whether he is going to put in the stripes of the shirt, which are white against pink. It seems he hasn't quite made up his mind about that.

During the sitting he quotes in German a poem by Schiller, 'Der Taucher' ('The Diver'), which his mother used to read to him when he was a child in Berlin and he loved very much. LF has a remarkable memory for verse of all kinds.

He quotes W. H. Auden, Philip Larkin, Lord Byron, all favourites. Also, less predictably, he performs comic verse and songs verbatim. A few sessions ago, he recited the whole of 'Lord Lundy, Who was too Freely Moved to Tears, and thereby ruined his Political Career'.

It concludes with a crushing admonition from Lord Lundy's grandfather, the Duke:

'Sir! you have disappointed us!
We had intended you to be
The next Prime Minister but three:
The stocks were sold; the Press was squared:
The Middle Class was quite prepared.
But as it is! … My language fails!
Go out and govern New South Wales!'

Hilaire Belloc was an influence on LF's own juvenile verse. 'At school I wrote a number of jokey, comic poems, which were published in a sort of pretend private edition. My brother eventually quoted one of them in a cookery column, which really infuriated me. The poem was called "Ode to a Fried Egg". It ended:

Here upon my chalk-white plate you sit
Greasy and disgusting … ugh!'

Another, printed in LF's prep-school magazine, was on worms. In part it goes, 'Worms have no tongues so they cannot lie,/They have no eyes so they cannot cry.' And it ends, 'Moral: We should have sympathy for worms.'

This week I have entered a state of Buddhist calm, in which I don't really care how long it takes, though even so it would be nice to see a new area appear. And this evening it does. It's a relief that LF has just broached something hitherto untouched: my shirt. It goes in very quickly, in strokes of deliciously fresh pink paint, no stripes.

For all that he thinks of people as nudes wearing clothes, LF has very strong feelings about dress. If he likes an item, he takes a sensual pleasure in it, stroking the leather of my new briefcase, for example, in appreciation.

Similarly, LF is hyper-conscious of the relation between an outfit and its wearer. When we went to the Royal Festival Hall some years ago, to a concert by Ray Charles, one of his comments was: 'He *really* knows how to wear clothes.' He thinks of dressing as something between a skill and an instinct, and whether it is done well or badly, it conveys a mass of information about the person inside the garments.

Fifty years ago, LF points out, clothes were crucial in a way that they are not today. 'It was quite impossible, for example,

for a gentleman to go out without a hat. Once Truman Capote [an acquaintance through Cecil Beaton], on first arriving in Britain, booked himself into the Ritz. The clerk at reception took one look at him – a diminutive figure no bigger than a child with a high-pitched voice and a scarf that reached down to his ankles – panicked, and pretended to have lost the booking.'

'At one stage I thought my life wasn't going quite as well as it should have done and I decided it was because of my clothes. Taxis wouldn't stop for me, that kind of thing; I wasn't allowed into certain places. You might say it was because the taxi drivers had detected my anarchic temperament, but in fact the taxis did start stopping again after I went to a very grand tailor's. When I first arrived for a fitting, the grand tailor looked at the clothes I was wearing – an off-the-peg Italian version of a Zoot suit from San Remo – and said, "Now that's a most *interestingly* cut suit, sir, where did you get it?" I thought that showed great style.'

LF responds to garments almost as if they were people, with their own personalities. He is also fascinated by the way, consciously or unconsciously, as with Ray Charles's suit, they express their wearer's individuality. He once painted a portrait of a friend in a ghastly shirt, 'because it was just the sort of ghastly shirt he would think was rather smart'. What my clothes say about me I am not sure, and LF certainly doesn't say.

...

After the sitting: 'The shirt was very helpful,' LF muses, 'as soon as I had put it in I began to see how it could work structurally.' I am not quite sure what he means by that, except that one of my ear lobes soon turned the very same pink.

On the other hand, putting in the scarf he found 'demoralizing' because when the blue went in it revealed that the face was still, as he puts it, 'at an early stage', by which he means not near to being finished, I suppose.

Another thing that LF finds demoralizing is working on the picture – which began near the winter solstice – when it is still full daylight at seven o'clock, though the shutters are closed and the electric light is on. 'On the other hand, it now becomes a luxury when there is real darkness outside.'

I arrive unusually dishevelled, having had a long and complicated day. First, I gave a talk to patients at a hospice where my friend Richard Dorment, the *Daily Telegraph* art critic, arranges lectures. Then I had lunch with him, and next – having dropped into the Cy Twombly works on paper exhibition at the Serpentine Gallery en route – I spent the afternoon in the V&A library, delving into books and articles about Van Gogh.

The net result of all this activity is that my hair is sticking out all over the place. LF is stimulated by this sight. 'I had expected to paint a shirt this evening, instead I find I am painting hair. It's a good sign when I change plan like that.'

Surreptitiously, I try to sweep it back, and LF's jaw drops in mock horror. When I next get up to 'take a stretch' I see that an unruly strand of grey hair has appeared, dropping across my forehead. 'It's been there before, it helps a lot,' he explains with satisfaction. In fact, in the past from

time to time LF has asked me to remove it. Now it's here, it seems, to stay.

He had begun by mixing up a series of greyish shades and filling in the ground behind my head – which had retained an aureole of white canvas up to this point. Then he took the hair out to the same point, and seemed pleased with the result. 'The shape of the head has come out much more.'

...

At Locanda Locatelli, after we have finished our main course (*bollito misto*), one of our napkins catches fire. It is lying on the table, and a corner of it is touching a small candle in a low holder. Quite suddenly, there are flames rising from the debris of our meal. I throw it on the floor, stamp on it, and the smoking remains are efficiently whisked away so that few of the other diners have any idea that they briefly faced a threat of immolation.

Personally, I am embarrassed and a little shaken by the incident, but LF seems stimulated. 'Maybe it's because I'm a suppressed pyromaniac, but every time I see flames and sparks I think, Hooray!' This is a small example of the way that his reaction to risk and danger is the reverse of – I would guess – the norm. Another is an early memory he relates of ice-skating in the Tiergarten, Berlin, before he and his family emigrated to Britain in 1932. 'Once I skated through a tunnel and as I emerged the ice broke and I went in and was fished out by a man who rushed from the shore. It was very exciting.'

When LF and Caroline Blackwood were staying near Biarritz in the early 1950s, he used to like to go bathing at places where there was a sign saying, 'Danger, No Bathing'.

'It made me feel rather dashing. I used to like to jump into an oncoming wave so that I was thrown back like a fish. One day the sea was quite high and I mistimed it, and instead of being thrown in I was sucked out. I'm quite a strong swimmer but I soon realized that there was nothing I could do about it. Before long, I'd swallowed some water, so I thought that was that. It was quite a pleasant sensation, just drifting away.'

'Then along came a rowing boat. But when it got close, I saw that the person in it was someone I very much disliked. He was staying with the same party that we were, a Frenchman who had made a lot of money out of bricks. We used to call him "la Bricque". He would say ridiculous things, such as, "A woman should be played like a violin." Caroline would ask, "How exactly do you perform?" Everyone knew his wife was having an affair with one of the other guests.'

'Previously, I had been shouting "Help!" but when he got close I pretended I had been coughing. That evening he said, "H'm, I think I saved your life today." I replied, "Not at all, I was enjoying myself."'

It's the last bit that is characteristic. Just as when he fell through the ice in the Tiergarten, LF found the experience not terrifying or shocking, but exciting. This attitude has had an effect on his painting, most of all in providing the nerve necessary to carry on with it. There was a period, a long period, starting in the early 1960s, when he carried on despite the fact that his work was thoroughly out of fashion. This was the high noon of British pop art, op art and abstraction. What LF was doing must have seemed passé, the idiom of the previous decade. Furthermore, he had radically changed his way of working, painting with broad, loose strokes of the brush

rather than tight, meticulous surface detail – and had thus alienated some of his earlier supporters.

'My pictures weren't selling. I had a dealer but they neither sold my things nor exhibited them. Suddenly I found I had no income. The position began to improve in the seventies, and more in the eighties. I think gambling helped me about money, because it made me less concerned about it.'

That period was a substantial chunk of his middle years – from around the point he turned forty to when he was sixty. LF had commitments, including two divorced wives and a number of children. Many people in the art world thought what he was doing was a dead end. An artist, a famous one, who was a neighbour of his at one time, told LF that he could not 'get' his work at all. '"I can't see the point in it, why you do it." I told him not to worry about it.'

'Did that kind of remark upset you?'

'No, it wasn't as though I was producing a product for customers. It was something I was doing as the result of a decision.'

So he just carried on, working slowly at his own pace and, moreover, behaving in a way that a more conventional temperament would have thought utter folly, by gambling heavily. Perversely, LF actually seems to have derived satisfaction from being ignored.

'I found there was something exhilarating in being forgotten, almost working underground. I've never wanted attention, so I didn't find it in the least unnerving.'

'At that time I was living in a street near Paddington. They called it "bug alley" and it actually was full of bugs, though I got rid of the ones in the studio. The woman below said it was a shame that they had put a factory above her. The room was very narrow, which I think is why I painted a lot of very big heads in it.'

This is an interesting demonstration of the effect the physical space of the studio has on the works that are made in it. There is often an expansive quality to the paintings that come out of the rather grand double Georgian room where I am posing. The heads he is talking about, from the early 1960s, on the other hand, have an almost claustrophobic intimacy.

11 May 2004

There were some sharp remarks in the *Evening Standard* about Stephen Spender – a friend of LF's in the 1930s and 1940s – but on the whole he agrees with the criticisms. He remembers W. H. Auden, whom he knew through a friend of his parents, saying of Stephen Spender: "'I think we'll make a comic poet of him," and I was hugely flattered by that "we", but I also thought it was a most acute judgment. In so far as Stephen had any talents at all, they lay in that direction.'

LF diagnoses a failure of character, which some might think a minor virtue.

'Stephen wanted to be liked, which isn't the best idea.'

'Better than wanting to be disliked perhaps.'

'My idea was always to be feared.'

'How do you mean?'

'Well, obviously, not to have people taking cover when I approached, but being thought to be a bit formidable.'

Auden made another remark that has stuck in LF's mind for decades. One day they were talking about commissions, and Auden said that in a way every work an artist makes or a writer writes is a commission: a commission from himself.

That is, he (or she) makes a decision to do it, which order is then carried out.

The question of formal commissions, however, is awkward for LF whose work is both intimate and in a way a matter of truth telling. For him, to undertake to paint the portrait of a stranger is chancy. It may turn out that he has no affinity with the person, no impulse to work from them. Furthermore, because of his methods, he will be cooped up in a confined and intimate space with the subject for many, many hours. Furthermore, he has a sort of private moral code. 'I do things on impulse, or alternatively don't do them – also on impulse – even if doing them or not doing them would be unwise or inconvenient. I feel that to do otherwise would be foreign to my nature.'

This evidently applies to both his life and his work. All of these circumstances make commissioned pictures, the opposite of painting a subject on impulse, problematic for him. During a break, he relates a story that illustrates the difficulties.

'Long ago, in the 1960s, when I was living in Gloucester Terrace, I got a letter from an Oxbridge college, from a physics don, who wrote that they were looking for an artist to paint the portrait of the Master of the college. After long and intense discussions, their choice had fallen on me, so would I kindly consider the commission. I replied that I seldom or never accepted commissions, but in any case I could not say until I had had a look at the Master whether I would be able to paint him. The don replied that if I inspected the Master – he had previously been headmaster of a famous school – and I rejected him he might be very upset. So this suggestion was impossible.'

'I wrote back to say, "Well said! Let's forget about the whole idea." He then sent a letter describing how he had thought of an ingenious scheme. I could be invited to a college feast and seated in such a way that I might be able to observe the Master without him being aware of it. So I went up to the college and had a very nice dinner. I was at a table with the physics don and another fellow and we had a very lively conversation during which I was thinking, How amazing, here I am having a conversation with a physicist!'

'The Master was a nice gingery-grey colour, which is a good combination, so I said I might try to do it. They asked me how much I wanted, and I said £1,000 – which was a lot of money at the time. They then asked why I wanted such an enormous sum. Even if they had selected someone really famous, they protested, it would only have cost them £800. They would have to pass a special motion of the governing body. Would I accept £800? So I agreed to that as a first payment, explaining that I was very uneasy about the whole project, that I almost never did commissions, and so on.'

'So it was arranged that I would have dinner with the Master, who appeared with a very nice daughter. He turned out to be pompous in a very headmasterly fashion, given to asking questions that had to be answered. [LF in deep academic voice] "Tell me now, your painting contains all manner of dots, blobs and squiggles of pigment, what are we to make of those?"'

'We had a few sittings at which he would ask me these questions. Alternatively, he would go to sleep, but not in a relaxed way. He would nod off, then suddenly jerk awake. In the end I wrote a letter saying that I simply could not work in the same room as this man, and the physics don wrote back saying what a tragedy it was.'

'A couple of weeks later, there was a ring on the doorbell, and there was the Master in full evening dress: "Don't mince your words, Freud. Tell me, what's the matter with me?" I said, "It's nothing to do with you, it's to do with me." But what could I say? After that I looked every day for his obituary, because he had looked rather mortal to me, and eventually after four years or so, there it was.'

So even though the portrait sittings didn't work, it seems they had a diagnostic function, a little as mine has revealed a fluctuating sensibility I didn't previously realize I had.

14 May 2004

My birthday: another year older and half a year passed since this picture began. The experience of sitting in this pool of light, being examined so closely, is a curious one. Staring, as LF stares constantly at me, is in ordinary life a disconcerting, even threatening, act. As McNeill puts it in his book *The Face*: 'Staring is special. Our mental gaze-radar detects it quickly, and even if we are utterly safe, we feel a quiver of warning inside. The omen is visceral, deep, oddly maddening. And it's not just psychological. Being stared at increases arousal, raising the heartbeat and altering the galvanic skin response, especially if the victim cannot counter or escape.' In pubs, staring can be a provocation to fight.

But in the studio being under ceaseless observation does not feel like that. It is as if even at a deep instinctive level, you realize that – as in a doctor's surgery or a hairdresser's shop – it is not you that is under scrutiny, at any particular moment,

but only an aspect of you. How, for example, the muscles connect together beneath your cheek.

The overall effect is more disconnecting than disconcerting. You are unusually conscious of the surface of yourself – the skin, the flesh, and consequently of what is inside the bubble: a mass of buzzing thoughts and sensations. It raises the question that occurs to everybody in childhood, and at intervals thereafter. What is this thing called 'me'? That is of course the central enigma of portraiture.

The painter Michael Andrews did a series of pictures of balloons, flying silently above the earth: his metaphor for the ego. One, perhaps the best in LF's view, shows just the shadow of the balloon on the surface below. Sometimes, posing feels like that: just floating, a little container of personality, surrounded by light.

...

There is a possibility, when looking at one's own image, of succumbing to a certain sort of vertigo. If you look too long at a written word, or repeat it to yourself too often, it seems to drain of meaning and become strange and arbitrary. Something similar can happen if you look too hard at your own familiar features.

There is an anecdote about Gogol, who seems to have suffered from vertigo of word and image simultaneously. Apparently, the writer was in the 'habit of long and continuous self-contemplation in front of a mirror, when, completely self-absorbed, he would repeatedly call out his own name with a sense of alienation and revulsion'.

...

When the American anthropologist Edmund Carpenter first took Polaroid photographs of certain tribesmen in the remote highlands of New Guinea, they were puzzled that they could not recognize themselves, never having seen such two-dimensional images before. They then took the snaps away and studied them in private; eventually some of them returned with the Polaroids attached to their foreheads, as a visible sign of themselves. Perhaps this is roughly what is happening to me. Never having looked at myself before with this level of intensity and in such detail, and through the objective eye of another, I am at first puzzled by what I see. Eventually, I may accept it as a surrogate for myself, whatever that means. This is what, rightly or wrongly, we often do with portraits.

18 May 2004

During a break, we return to the question of commissions, of which LF says he has done very few over the years.

'I did one of Bernard Walsh, the owner of Wheeler's restaurant in Soho, where I used to go a great deal – we all did, and we all had accounts. He wanted a painting of me by Francis and a painting of Francis by me. In the end, Francis did give him a picture of me, and I did this portrait of Walsh himself, which hasn't appeared again, I am glad to say. It wasn't a complete failure, otherwise I would never have let it out of the studio, but I had tried to work in a different way – more thinly – and I don't think it really came off.'

There is an odd asymmetry about LF's picture of Francis Bacon and Bacon's of Freud. LF painted Bacon only twice, and

drew him a few times, but the first of those pictures – the portrait from 1952 which was stolen from an exhibition in Berlin in 1988 and has not been recovered – is or was a masterpiece: an extraordinary depiction of calm containing inner tension. The others, even the quick drawings, including one of Bacon with his trousers half undone, are memorable, with a vivid sense of the sitter. The numerous Bacons of LF are somehow duller than those of his other regular sitters – Isabel Rawsthorne, Henrietta Moraes and George Dyer – as if the essence of the sitter eluded him.

I asked about the marvellous, stolen portrait of Bacon. Did it require dozens of hours of posing, as usual? And if so, how had Bacon felt about this sacrifice of potential opportunity to work?

'I always take a long time,' LF says, 'but I don't remember the picture of Francis taking all that long. He complained a lot about sitting – which he always did about everything – but not to me at all. I heard from people in the pub. He was very good about it.'

It sounds as though LF, on the other hand, wasn't that cooperative about modelling for Bacon in return. 'I sat for one picture, and I thought it was pretty good a bit before the end, then he spoilt it.' He confesses, 'I'm no good at sitting.' I imagine he's too restless. Most of the Bacons of LF, like most of Bacon's pictures of people, were done from photographs.

'I don't think they are among his best things,' LF reflects, 'but', he carries on, 'almost everything he did at that time – in the late forties and early fifties – when he didn't have a style – was good. Once I used to have a lot of Francis's paintings that he gave me or I bought. There was a very good one of William Blake, which is now in the Tate, which got left in the house when I split up with Caroline. She sold it; I didn't mind, although it was really mine. He gave me one of the popes with the tassel swinging across – you could almost see it move –

and also a picture he did of two figures silhouetted against a blind in the South of France – which was very odd and witty.'

…

When he finishes, LF says he wants 'the forms a little less broken up'. It sounds, I deduce hopefully, as if the end is approaching.

20 May 2004

LF applied himself only to the ground and my hair, predictably making it greyer, which had the effect – probably his intention – of making it stand out more. 'It wouldn't work at all if I thought of it as background. That's why I probably won't do any more until I've done more to the head.' This is the opposite of what he said at the end of the last session, when he worked a good deal on the shirt and started the jacket. 'I think I will now cover the whole canvas, then I'll be able to see the head more.' This just goes to show that, as he says, he doesn't have a method.

…

The living, individual quality of the ground is crucial to what he does. When he made an etching (p. 187) of Chardin's *Young Schoolmistress* (1735–36; p. 186), a picture of which he produced a series of copies – or rather re-imaginings and explorations in different media – the ground swirled and eddied around the head of the two figures as if it was moved by powerful seismic, or psychic, forces.

Jean-Siméon Chardin, *The Young Schoolmistress*, 1735–36

After Chardin, 2000

Making the figure and its environment one organic whole in this way is the reverse of what Francis Bacon used to attack as 'illustration'. But, as is often the case with people who attack faults, Bacon was liable to lapse into illustration himself, in LF's view.

'Having a plain-coloured background and putting the subject matter as such on it is, one can really say, a recipe for illustration. Of course, the best things, when Francis worked on the whole canvas and livened it up, are very different. But when he simply put, as he did later more and more and more frequently, something onto the dark blue or green canvas without it relating in *any* way, well of course the result was illustration.'

. . .

LF told me last week he has been struck by a dental crisis. His dentist has said that he must lose his top front teeth. When I ask when, he says, 'Within the next six months, that kind of thing.' It seems that they are very fragilely anchored, and his dentist has told him it will not be possible to keep them in without bridge-work, implants or possibly a plate. LF feels that the last especially would distract him from painting, which is the main objective of his life. He feels that he would constantly be considering where he put it, and so on. His reaction was that he would not put up with the inconvenience of any of the suggested treatments. Instead, he immediately began to plan a *Self Portrait with No Front Teeth*.

It turns out, however, that LF's teeth have been reprieved. The dentist evidently came up with a plan B. 'Oh, if I took them out I'd have nothing to work on.' LF is relieved; he'd been starting to worry about whether he'd be able to eat properly without front teeth. LF observes, somewhat in contradiction

to his earlier decision, that teeth are so essential that dentistry is a case in which the price is absolutely no object.

He insists, however, 'I don't mind at all what I look like. I'm only interested in how other people look.' He told the dentist about his planned toothless self portrait and the dentist remarked, 'Well, I hope you weren't intending to put the name of your dentist beside the title.' All the same, one suspects that might have been a marvellous picture: a remorselessly truthful record of physical decay.

When talking about Titian's *Diana and Actaeon* and *Diana and Callisto*, he once remarked, 'They have what every good picture has to have, which is a little bit of poison. In the case of a painting, the poison cannot be isolated and diagnosed as it could be in food. Instead it might take the form of an attitude. A sense of mortality could be the poison in a picture, as it is in these.' It certainly would in *Self Portrait with No Front Teeth*.

Much of LF's own work has that sense of mortality. Even images of the young and healthy are full of a sense of the soft vulnerability of flesh, its potential to sag and wither. One is aware of the inexorable passing of time, but the effect is not horrifying, merely truthful.

In his self portraits LF seizes almost gleefully on signs of ageing and time (perhaps this is also what he means about fearing death being a great disadvantage for any painter). LF's attitude to other sitters is in this way the same as his attitude to himself.

. . .

LF's exact, unsentimental yet sympathetic observation of human decline comes out in his description of the last years

of Nina Hamnett, a doughty Bohemian of the Edwardian
generation. Hamnett had a fling with Amedeo Modigliani;
posed naked for Henri Gaudier-Brzeska for a famous carving
entitled *Torso*; and was – almost but not quite – a significant
artist in her own right before becoming a fixture in the water-
ing holes of Soho and Fitzrovia in the 1930s, which was where
LF encountered her.

'I met her the first time I went into a pub, which was the
Fitzroy Tavern, when I was about fifteen, and she was there, as
she always was. When I went to Wales, I sent her a postcard
asking, "Are you still drunk?" She was very angry when I got
back to London, "How could you send a card like that?" She was
right, it was very rude; everybody had seen it. I was a bit proud
to know her, and whenever I had seen her she was drunk.'

'She was derelict but very brave, and she had some judg-
ment about behaviour. When she asked you for money it was in
a spirit of, "Oh, I just happen to have left my purse behind, do
you think you could possibly help?"'

'I was always sort of pleased to see her. She was a good
person, which perhaps made her a bit vulnerable in comparison
with some people who were hanging about in that world, more
or less living off other people. For example, I have heard from
talking to people who knew her when she was young that she
would never go with anyone simply because they had money.'

'I took a publisher friend to see her one day, I think there
was some question of her doing a second volume of memoirs
(she had published one called *Laughing Torso*, ghastly title, but
she would have had no sense of words, she was a painter). Nina
said, "Would you like a cup of tea? I've been keeping it warm for
you." She threw back the blankets on her bed, and there she
was, curling up around the teapot. That was spectacular.'

'Towards the end, she had moved into a house near me in Delamere Terrace and at that time she had a lover who was a sailor, at least twenty-five years younger than her. He left her and she jumped out of the window, or perhaps she fell (in a way, I rather hope she fell).'

'I went to visit her in the hospital, and there was this bit of broken person in a bed. Her sister, whom I'd never met before, was there, sitting beside the bed saying things such as, "Isn't that just like old Nina?", and reaching over and moving her head about. She lifted the sheets, and there was blood and broken bones. Nina was unconscious, and then she died. There was some question about who was going to pay the costs of the burial and so I paid.'

There is an observant sympathy in that description which reminds me of his etching of the dog Pluto, done when the animal was old, arthritic, losing its sight and close to death. LF added a hand, almost disembodied like the hand of God in medieval art, because he felt the creature needed some company.

I get halfway to the station then realize that I have left the blue scarf behind. The portrait, begun in mid-winter, is now moving into summer, but I am still dressed in tweed jacket and scarf, the latter being a particularly odd item to bring with you in these temperatures. Just transporting the costume is becoming an undertaking.

The previous day having been scorching hot, I thought I couldn't wear my tweed jacket. In the end, I substituted

a dark-blue linen one of a similar general tone and colour, and carried the tweed one in a bag in case LF insisted on exactly the same outfit.

In the event, he decided he preferred the linen one anyway. 'It's very nice over the shoulders.' I wonder whether this lets him off doing the pattern in the tweed, about which he was unsure. But then the stripe in the pink shirt he has simply ignored.

...

We discuss the fire at the Momart warehouse, which took place last night. According to reports, large quantities of work from Charles Saatchi's collection have been destroyed, including pieces by Tracey Emin and the Chapman brothers. LF suggests, 'Some people will say this proves there is a God,' which is not at all a comment on the art that has been incinerated, but on the malice that was felt against it. Malice is a subject that interests him.

LF met Verity, my opposite number these days as a night model (p. 193), through Momart and he says that she is utterly devoted to the organization. The fact that she is posing for him has been discovered by the press, and she is being pursued by a man from the *Daily Mail*. LF himself was caught by paparazzi outside the Wolscley with another model, suggested by his daughter Bella, who didn't work out.

This ambush made LF absolutely furious: 'I hate having anything flashed in my eyes. If I had had a gun with me I would have used it.' For a while afterwards he wore his battered panama hat so as to protect himself from photographic flashers, thinking to shield his face with it.

Naked Portrait, 2004

LF is phobic about being photographed, even without a flash. Years ago, while we were having lunch at St John in Smithfield one day, he got the impression that another diner was taking a picture of him. Immediately, he stood up and began to bombard this young man – who turned out to have been snapping a friend at another table – with bread rolls.

His objection to paparazzi is partly that, as he explained, he dislikes bright lights being suddenly shone in his eyes, a perfectly understandable feeling on the part of someone to whom sight is crucial. But it is more than that. He is not keen to be observed, especially to have his image snatched surreptitiously. Although he has been a public figure, and of interest to the press, from an early age, he defines his temperament as 'secretive, or at any rate, *private*'. And this is true of his work. It is the product of an extended observation of minute closeness, of intimacy.

Consequently, his own popularity slightly puzzles him, 'because my things are private, not like the work of some artists who want to make a public gesture or statement. I sometimes wonder who all these people are who went to my exhibition.'

LF has a rooted objection to doing things in crowds and groups. His politics, in so far as they exist, are anarchic; he quotes the old anarchist view that it's unwise to vote for anybody you don't know personally. 'On my school reports it used to say "takes no part in communal activities". So, I thought, at least I'm getting something right.'

His voyage to Jamaica in the early 1950s on a banana boat was hell for him, because of being confined in a community of forty other, unavoidable, passengers.

'At one point a notice was put up, saying "Tomorrow night there will be a Brains Trust", which was to be chaired by me and another passenger who was a university lecturer. I went to

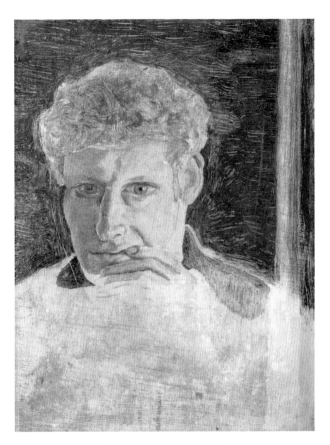

Self Portrait (unfinished), 1952

After Chardin, 2000

the purser's office and said that if I had been asked to do this, the answer would certainly have been "No". He said, "Oh, be a sport." I replied that a sport was unfortunately something that I was not. I did a little self portrait of myself while I was on board, biting my finger, looking in the mirror alone in the cabin bathroom (p. 195).'

27 May 2004

After the sitting yesterday, over dinner of mackerel, prawns and a salad made from an ornate fungus, and following a long pause, I asked what LF was thinking about: 'I was thinking about your ear.'

At the start of the session today I ask him what he meant by that. 'I was worried that I might have painted it like another painter who wasn't me, but when I got back and looked at it I realized that it was all right – just a bit wild.'

LF is especially interested in ears, which feature quite prominently in his images of people (as the sexual parts do in his naked portraits). One of the things that drew him to Chardin's *Young Schoolmistress* was her ear (p. 196). She has, he says, 'the most beautiful ear in art'.

...

Audacious to the point of recklessness as LF was – especially in his youth – there are limits to his quest for humanity in all its varieties. He tells me about a man named Eddie the Killer, who evidently fascinated him at one point in – it seems – the early 1960s.

'Even the criminals I knew in Paddington were frightened of him. "You don't want to have nothing to do with the Killer, Lu." He was never caught for any of the murders he committed, because they were completely without motive. He had made money from threats and robberies and used it to buy property and businesses. I remember meeting him in Mayfair on my way to a gallery in Bruton Street, and he said, "Oh, I own some houses along there," which even in those days must have been very valuable.'

'He was interested in art a bit, and one of his associates named Charlie became an art dealer. He was bringing some paintings to show him one day when we met in a pub. Charlie was saying Killer this and Killer that; Eddie said, "Not so much of the Killer," then, to me: "I don't do them silly things no more, Lu." He was a psychopath.'

'He would say to me, "You're a strange bloke, Lu. You never tell me where you live." But I didn't. Eddie himself lived in a house Thomas Hardy had lived in in London, so I gave him a nice edition of Hardy. Upstairs in this house, I discovered, there was a room where Eddie's brother had hanged himself, which was closed and he never entered. I thought about painting Eddie, then I thought perhaps I'd better not.'

15 June 2004

We have started afternoon sittings to try to speed the picture towards a conclusion. LF offers me lunch from time to time: cold rack of lamb with peas and potatoes, and a

glass of claret; rillettes and ham with olive paste. Today, tongue, an old-fashioned dish of which LF says he eats quite a lot. I turn down the offer of champagne or claret as it seems too hot to drink in the middle of the day.

I ask about his habit of leaving the white patches of bare canvas, which could easily be filled in. 'It makes it more difficult to get the tones, which somehow helps me. I like to think that everything in the picture is changeable, removable and provisional. Leaving the white patches helps me to feel that.'

But this afternoon he removed the lower white corners, so the jacket looks almost completed. Does this mean that the end is in sight? I suspect there are a few more sittings to go, at minimum. At the end of the last session I carelessly referred to the face as finished. LF responded: 'It certainly is not, though it looks quite close.' He added, a little ominously, that the horse picture, which is linked in his mind with this one, 'began with a bang and finished with a bang. This one just goes further and further.'

LF has taken to carefully arranging my scarf, shirt and jacket, the scarf particularly, muttering remarks to himself, such as 'Oh, yes, I see'. Rather than simply painting my clothes, he is working out how to make visual architecture out of them: 'I paint clothes in portraits because people wear clothes, but I want them to be there to help the picture.'

On this occasion, he has added some shadows on the scarf and the jacket. As we started, looking at it, he said, 'Oh, I got much further this time. Now I can accept it much more.'

We have gone back to evening sessions. LF has shown the picture to Edward King, director of the Abbot Hall Art Gallery in Kendal, who seemed impressed by it. He jumped and said, 'That is Martin!' – as LF's sitters often end up feeling, 'It really is me!'

Actually, though I almost share that reaction, there are one or two features that I wonder about, for example, the nose. Mine has a bit of a twist, but the nose in the painting seems at once more bent and more prominent than my own. I guess it has been enlarged and also given a certain baroque energy to improve the painting (rather than the likeness).

This isn't quite such an unsettling sensation as that experienced by a character in a short story by Gogol, who wakes to find his nose has departed to take up life on its own account. It goes round St Petersburg in a hat and overcoat, claiming an official rank, while its bereft possessor skulks with a handkerchief pressed to an embarrassing blank zone in the middle of his face.

To be given someone else's nose in a picture isn't nearly so bad. I can see that my nose, though perfectly satisfactory for my purposes, isn't quite up to the dynamic visual task that LF requires of the nose in the painting. He wants it to fill the middle of the image with a flourish. I suspect that he may have given me his own nose.

I mention a theory that I've developed about Gauguin's portrait of Van Gogh, *The Painter of Sunflowers* (p. 201), done while they were living together in Arles in the autumn of 1888 (and during a phase when their relationship was breaking down). The picture looks most unlike other images of Van Gogh, in hair colour, shape of face, angle of nose – in all sorts

Paul Gauguin, *The Painter of Sunflowers*, 1888

of ways. It actually looks, it seems to me, much more like Gauguin himself. LF agrees that this is quite possible, though probably unconscious, because painters quite often make others after their own images in this way.

Noses, an important aspect of facial geography, are obviously of great interest to a portrait painter. But more than that, I suspect LF is drawn to items of anatomy that are idiosyncratic and convoluted – rather as he likes his sitters' personalities to be: ears, noses, genitals, and also digits such as toes. Talking about Titian's *Diana and Actaeon*, he once asked rhetorically, 'How did Titian know that particularly wonderful nymph sitting on the ledge of the fountain in *Diana and Actaeon* so well? We recognize her immediately by her amazing toes.' LF evidently *could* identify someone from their feet.

There is a correspondence here with his tastes in food. He often chooses shellfish – *zuppa di pesce*, say, or *moules marinière* – methodically extracting the complex creatures from their shells; game is another common selection, which he likes for its wildness: again, like his sitters.

...

We talk about animals, in which LF is extremely interested, though it would not be quite accurate to call him an animal lover. He has a series of nuanced but strong reactions to distinct animal personalities (just as he has to human ones). For horses he has a deep affinity, but cats, for example, he finds irritating. 'I don't like their chichi affected air of independence, nor the way that they come and sit on your lap with an air of "Now you may stroke me".'

Pluto Aged Twelve, 2000

Lucian Freud with a fox, 2005

Dogs he has often depicted, and owned. The late Pluto was a sitter for a number of works over the years, both paintings and etchings (p. 203), with and without human companions. Now Eli, David Dawson's dog – a relation of Pluto's – is an equally frequent model. But LF feels that he and dogs are not ideally compatible.

'The only thing I don't like about dogs is their so-called doglike devotion.' One can see he might find them a little clingy; on the other hand, he recognizes that he is not an ideal dog owner. 'It's a dog's life for a dog living with me, because I have a hatred of habit and routine, and that's just what dogs love. They like regular everyday everything, and I don't have regular anything. I have a timetable but no routine.'

Nonetheless, in an encounter with a feral canine, he felt he had met an opposing and, in its way, formidable spirit. 'Once I was walking up one of the side roads around here when I saw a very large dog-fox in front of me, so big that it looked as if it might have been mixed with a bit of Alsatian. There were grey bits on it too. It heard me coming up behind it and looked round and just glared at me. It looked so furious. I thought, right! I took it as a challenge and increased my speed to catch up with it. It finally whisked away under the gates of a factory.'

Other animals have come in and out of LF's world with their owners. 'I had a girlfriend once in Scotland who had a white laboratory rat that lived under her blouse. I had one too, it was a kind of bond between us. She also had a monkey, which used to sleep on my head when we were together. I didn't much like that.'

As far as posing, as with humans, practicalities come into the question. His dogs have happily sat for their portraits: 'They are bred to it.' Pigs are another species he finds congenial,

Lobster, 1944

warming to their amiable self-sufficiency. But how would he get them to pose? He considered keeping them in his back garden, but imagined they would root it up, make a smell, and the neighbours would complain. What he needs is a suitable pig farm within reach of central London where he could work quietly in a sty, but such a place is not easy to find. A Freudian pig painting, however, would be fascinating to see.

Similar considerations explain the non-human cadavers that turn up very frequently in LF's work of the mid-1940s. 'I had difficulties when I was young in getting models, live ones, which was why I think I drew and painted so many dead animals.'

Shellfish, oysters for instance, would be a marvellous still-life subject for him. He agrees, but keeping them through the long posing process is a problem. In the past he has depicted lobsters (p. 206) and prawns, but eggs are more suited to his methods.

\cdots

This evening he fills in the remaining blank sections of the upper canvas, but first repaints the jacket. 'Having looked at the picture in daylight – something I don't usually do with a night picture – I saw that the tone was wrong. That's much better. Now I shall be able to get going.' I must admit that it looks much the same to me.

Now only a tiny sliver of white remains between scarf and shirt that will probably soon turn into shirt. The scarf is almost a novelty in his work. 'I've never wanted beautiful colours in my pictures, for people to say, "You know, the picture with beautiful colour in it," but this blue is a beautiful colour.'

22 June 2004

LF has been to Paris and quite enjoyed the experience, 'though really there's nowhere I want to go'. Tonight he yet again repaints the jacket slightly, altering the line of the left shoulder. I remark that he seems to be having trouble with it. 'Oh, sometimes I spend weeks just painting and repainting the corner of a room or something.' This is said cheerfully. Much as I have enjoyed the whole process, my desire for it to be over and done with is now becoming intense. He then repaints the shirt collar, taking out a rather beautiful shadow on the left and which he has trouble putting back.

'It was nicely painted but roughly painted, and I don't like to paint roughly. All the way through with this painting, it's gone like that. First of all I painted something loosely, then more carefully.'

Although painting is not usually considered a conceptual art, a great deal of what LF does during the sessions of painting is actually thinking. Each mark is pondered in advance, evaluated when it goes down, and if necessary altered or removed. That is, of course, part of the normal process. What is unusual about LF, perhaps, is his persistence in carrying on and on doing this – considering, changing, again and again – until the result satisfies him. That is the point of the extraordinarily prolonged gestation period for each picture. 'The only secret', he says, 'I can claim to have is concentration, and that's something that can't be taught.'

...

Like actors, politicians are a type of person that LF has known, but not painted. 'One I knew a bit and thought was nice was Hugh Gaitskell. I used to go to nightclubs with him. He had a great passion for, and perhaps was in love with, a woman who was a great friend of mine: Anne Fleming. We went dancing together at Annabel's, which had just opened. One thing I liked about Gaitskell was that he was incautious.'

'"Do you really think I ought to go to the nightclub?" he asked. I answered: "Yes, I really think you should." So we went. I asked him if he really thought he was going to be Prime Minister, which was pretty rude. He answered, "I look ahead only one step at a time," which was a good answer I thought.' In fact, Gaitskell very probably would have become Prime Minister after the 1964 election, won by the party – Labour – that he led. But he died suddenly of a rare illness at the beginning of 1963.

Incaution is an unusual quality in politicians, who in general must guard their true feelings, watch their words, and – like actors – pretend to feel what they do not. It is allied to another quality that LF admires. This comes up when we are talking about a painter friend we have in common. 'He has a quality that only the very best people and the very worst have, he's absolutely shameless.' This was true of Francis Bacon, as is obvious from his behaviour when taken to Warwick House, home of the press magnate and Conservative politician Esmond Rothermere.

'At one time I used to go there very much, when my friend Anne Fleming was married to Esmond, to lunches and to parties. On one occasion, I took Francis Bacon along, very drunk. Princess Margaret – who was regarded as the most marvellous, glamorous person at that time – began to sing

some songs, very badly, accompanied by Noel Coward at the piano. Francis decided to start heckling and people became extraordinarily angry about it. Binkie Beaumont, the promoter, was one of the angriest. Because I was the one who had brought him, they turned on me, blaming me. Of course, in response I was fiercely defensive of Francis.'

'Another evening at Warwick House, Randolph Churchill approached him on the dance floor and asked in a very aggressive manner, "What on earth are you?" "Why," Francis answered, "I'm a nancy boy!" And Randolph just ran.'

Shamelessness is an attribute that was also possessed by Leigh Bowery, the performance artist who appeared so frequently in LF's work of the early 1990s that his overweight body and shaven head define a whole period of paintings. It was an era of robustly vigorous male nudes that remind me of Rodin's naked studies for the statue of Balzac (a cast of which strides in the corner of LF's kitchen).

Lack of shame can be a sort of moral quality, for good or ill, requiring bravery. LF famously said of his homosexual friends, such as Bacon and Bowery: 'I admire their courage.' It is easy to see how shamelessness might be an appealing trait in a model. Indeed, that is the impression that radiates from the Bowery pictures and also the ones that followed, of Bowery's friend Sue Tilley: unashamed of being naked, unashamed of looking unusual, unashamed of being fat.

Of course, shamelessness was also shown by Eddie the Killer, and Ronnie Kray, whom LF also knew. 'I liked Ronnie, not Reggie. I thought he was just a thug. But Ronnie said interesting things, although he was, as everybody knows, a sadistic murderer.'

...

LF has a great love of baths: 'I bathe two to three times a day.' On this warm evening, he suddenly said, 'I'll just be a minute', and reappeared a little later drying his hair with a towel, announcing that he had felt a little clammy and decided to take a quick bath. Of course, as a sitter, you are part of his domestic life. Sitters are almost always there, day after day, year after year; ordinary existence goes on around them. But this unscheduled wash may be a sign that the approaching completion of the picture is making him a bit jumpy, just as it makes me feel relieved. Also, it is an example of how he likes to remove any distracting factor: the canvas being too slack or his feeling a bit hot and sweaty himself. While he is out of the room, I notice how weighty and powerful the picture looks with the lights switched off. In the almost dark it is a looming presence.

After dinner, LF takes me to King's Cross in his taxi as it is raining, and drops me at a spot crowded with drunks, homeless beggars, prostitutes, and theatregoers returning home to the suburbs. He thinks it 'very lively', in fact he didn't know how animated it was around here and considers coming back. To a painter, I suppose, this chaotic scene is a cornucopia of potential subjects.

30 June 2004

Today, LF suddenly broke off with the words, 'I feel really nervous,' and went down to the kitchen to make himself a huge carrot-juice smoothie. 'Perhaps that will improve my colour sense.' The case of nerves, I diagnose,

is due to the fact that the picture now really does seem to be nearing completion.

The last few sessions have mainly been taken up with painting and repainting my shoulders. At one point there was a kink in the left one, and a discrepancy in height between the two of them. But that struck him as 'too fleeting'. The lapel appeared, only to vanish, then reappear. Now the line dividing the sleeve from the shoulder has come into view. 'The more paint goes on the jacket the better, to show it's different from the rest.'

'There's something I very much wanted to do, which was to put a darker shadow on this side of the face, to make it more rounded. That's now done.' Both my ears are repainted also. LF explains that he has included part of these that cannot in fact be seen from his normal vantage point, which explains why he periodically leans forward to look at the side of my head. At the end of the previous sitting, he had said 'there would only be one or two more'. But Wednesday did not prove to be the final one, nor Saturday.

On Monday: 'I've looked at it very hard, and now I know what I want to do.' It is tempting to lose patience, on the other hand he really is steadily if slowly increasing the sharpness and impact of the whole picture.

On Tuesday, the shirt collar and shirt become crisper and better. LF adds a few touches to the scarf and a little darkening to the background. He has decided not to put any layers over the very thin strokes that cover the ground, as 'to do that would make the head jump out too much'. David Dawson comes in to take a photograph and opens the shutters, letting a flood of light into the studio. It's disconcerting, as I've never seen them open before and the womb-like ambience of the room is immediately dissipated.

...

When asked why he painted Leigh Bowery so much, LF replied that it was because 'I thought he was very beautiful.'. Such qualities are and are not objective. In psychological tests, people of all nationalities, genders and ethnic groups, it seems, declare the same photographed faces to be attractive. But such objectivity diminishes sharply in experiments in which the actual people are introduced to each other. The more time they spend together, the less objective agreement there is.

In practice, attractiveness depends to a surprising extent on the individuality of the people involved. Of those married to identical twins, only 10 per cent declared that they might have fallen for the other – almost visually indiscernible – twin. This is entirely in line with LF's point of view. He is unsympathetic with references to people having, say, attractive eyes or legs or busts. 'I would have thought that if you wanted to be with someone, you would find *everything* about them erotic.'

Meeting one of the world's most celebrated beauties, he seems to have found her appearance largely an aspect of an eccentric personality. At one of the Warwick House lunches, LF encountered Greta Garbo, whose face was the most glamorously romantic, perhaps, of the mid-twentieth century.

'What did you think of her?'

'I thought she looked marvellous, but she was very silly. You know how Scandinavians can be silly? We were driving across Westminster Bridge, and she asked to stop because she wanted to walk barefoot in the rain. I felt we ought to get out too, and my best suit got wet. It wasn't the end of the world, but it was tiresome.'

'She was idiotic in a way, but she had an instinctive sense of style. When she decided to have her hair cut she went to

Selfridges and sat on a rocking horse and had a little boy's cut, which was crude but looked just perfect for her. I didn't find her physically attractive, for that I think the other person has to find you attractive. But I remember that when I went to visit her in her dressing room, she patted the sofa very close to where she was sitting herself – which was a Scandinavian thing to do – and I thought, Oh my goodness, this is exciting, sitting so close to this beautiful woman.'

Could Garbo have been a subject for LF? It sounds possible, though more because of her silliness and sense of style than her beauty.

...

Now the picture is virtually finished; indeed, to me, it looked absolutely completely so, but I agree to sit for an hour or two on Sunday, after which we are to go out for dinner with my wife and children. This should be the definitively final session.

4 July 2004

The sitting commences in the late afternoon. For some time I have been turning over in my mind the thought that I could volunteer to sit for another work, perhaps an etching. On the one hand, I am hugely relieved that the marathon of this painting is now – must be, surely – coming to an end. On the other, the process is enthralling. My interest hasn't run out. I want to see another portrait slowly grow.

When I tentatively mention that I would be ready to sit for another work, it turns out that LF is more or less assuming we

would carry on and do an etching. In fact, he suggests that if there's any time left over today after the painting is finished, he might start doing a drawing for the next. This urge to carry straight on is highly characteristic. When one work ends, another begins, and if possible the minimum amount of time should be left in between. This is a good practice, psychologically, for anyone whose work consists of a series of creative projects: it avoids the post-completion dip and the subsequent agonies of getting started again.

In the event, however, there is no such spare interval. At 6.35 p.m. LF says: 'These are the last touches going on now.' So I get up, he stops painting, we chat a little, then he says: 'I think I'll just do something about that little patch on the shirt collar.' So I sit down, he starts painting again and I begin to wonder how much longer the process might last. Then suddenly he announces: 'I think I'll stop now.' And that was that.

...

The picture is finished. I think, not that it makes any difference to its quality, that it looks very much like me. When Josephine arrives with Cecily and Tom, ringing the doorbell a few minutes after LF put his brushes down, she comments that in the studio photograph (p. 217) by David Dawson, the portrait looks more like me than I do (or rather, than the photograph of me does).

And it feels like me. Indeed, I sympathize with another Freud sitter in the Jake Auerbach/Bill Feaver film who said that the leg in the picture felt as if it was her leg. After a little discussion, the painting is given a title. Most of LF's pictures are not given the names of their sitters. In this case, the title

more or less suggests itself: *Man with a Blue Scarf.* So that's what it is.

Man with a Blue Scarf (p. 218) is in part, I think, a painting of my own fascination with the whole process of being painted. I see that intensity of interest in the picture. It's me looking at him looking at me. But as good pictures can be more than one thing at the same time, it also has a certain look of LF. Indeed, in David's photograph – in which LF with his palette and brushes looks like a wizard beside the easel – the painting looming behind appears to have the same gimlet gaze and craggily corrugated features as its creator.

Perhaps that's as one might expect. In his memoir *Avant et après*, Gauguin made a remark that seems relevant to his own picture of Vincent – and perhaps also to LF and me. 'Pictures and writings', he pointed out, 'are portraits of their authors.' In other words, all works of art and literature reflect the minds that created them. Gauguin's theory implies that *Man with a Blue Scarf* is a reflection of LF as much as of me. Conversely, I suppose these notes I am making, filled with my thoughts and impressions of him, are a sort of accidental self portrait.

Also, perhaps *Man with a Blue Scarf* is the result of a meeting. There are many elements caught in this image: time, passing moods, feelings. It's a record of all those hours of conversation, and of just silently being together in this room.

. . .

After Josephine and the children have admired the picture, we go upstairs to LF's sitting room and drink champagne, then take a taxi to the Wolseley. En route, LF – typically – broaches the subject of goats. He has been to see *The Goat,*

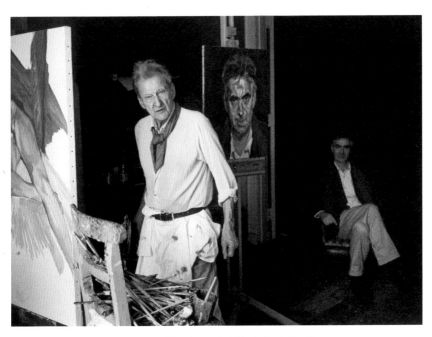

Lucian Freud, *Man with a Blue Scarf* and Martin Gayford, 14 June 2004

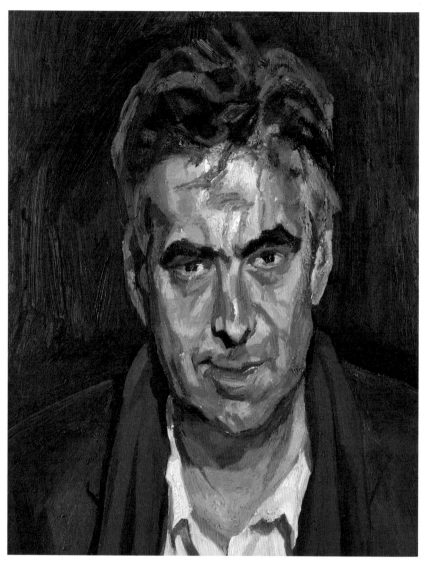

Man with a Blue Scarf, 2003–04

or, Who is Sylvia?, Edward Albee's play about an architect who falls in love with one of those creatures. LF explains that he knows a bit about goats, having looked after them at Dartington. He himself, it seems, has a grudging respect for the animals, very different from his warm sympathy for horses. But he felt what was described in the play showed no sense of goat-iness, in fact a complete lack of understanding of goat-like behaviour.

LF discusses the Duke of Wellington with twelve-year-old Tom, quoting the great general's terse solution to the problem of small birds infesting the Crystal Palace during the Great Exhibition of 1851: 'Sparrowhawks.' There is a quiet sense of celebration about the evening.

PORTRAIT HEAD

A fter a gap of a month, and a holiday, we began all over again on an etching. But it was not the same. With the change in medium, everything altered – including me. I was preoccupied with my own work, the book about Van Gogh, which I was now writing every day. It filled my mind, which was perhaps one reason why I made far fewer notes, and consequently – perhaps – can now recall less vividly what went on.

As time passed, the sittings became quieter and quieter, as we had less and less to say. It wasn't an embarrassing silence, but a companionable one. The mood however, was very different from that of the evening sessions in the spring.

We had agreed on afternoon sessions, giving me enough time to do a morning's work in Cambridge, then catch the train to London. And after lunch is a low-key time of day, while the evening has hints of excitement: both of us were a little tired, running down towards that late afternoon dip when Lucian takes a rest. In place of a glass of vintage claret, the normal refreshment was green tea at around four.

It was, though, a new lesson in the complications of portraiture. Having in the end been very happy to accept the *Man with a Blue Scarf* as an image of myself, I found the new work from the start slightly alien and unexpected. I was to get a demonstration of the truth of Van Gogh's remark, already quoted, that 'the same person supplies material for very diverse portraits'.

If *Man with a Blue Scarf* was a social portrait – me looking outwards, engaged with my surroundings – this turned out, not surprisingly under the circumstances, to be the opposite: at once contemplative and tense.

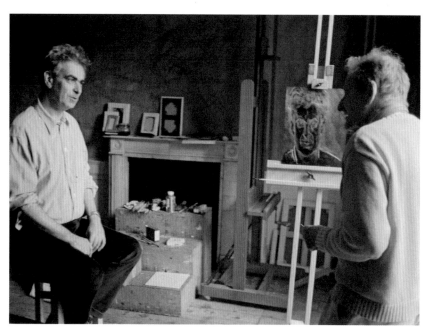

Martin Gayford and Lucian Freud, 2005

At the first session LF did two chalk drawings on the copper plate, then ended by rubbing both of them out. Looking at what he had done, before it disappeared, I hazarded that this was going to be quite unlike the *Man with a Blue Scarf*, which had gone to LF's dealer in New York to be sold.

'Oh, yes,' he replied decisively, '*really* unlike.' As it went on, I could see what he meant. This was going to be different in every way, not just medium, from the painted portrait.

For this work, I was sitting in daylight, perched on a stool and facing into the light that came through a big window at the back of the room. That itself gave the whole affair a less intense, more meditative, quality than the evening painting.

LF seemed happy with the arrangements. 'I think', he said at the end of the second session, 'that I've accidentally done a good drawing.' It seemed, to me, much less what I think I look like than the original sketch for the painting. My face looked elongated – more so than the painting, which lengthened my head a bit – and an oblong tangle of hair protruded from one side of my skull.

'Have you reversed my parting?'

'No, these are the forms I find in the hair.' The more he looked at it, the more fascinated LF became by the unruliness of my hair.

. . .

Etching is a different visual language from painting. Some artists who specialized in it, such as Jacques Callot in the early seventeenth century, and Piranesi in the eighteenth, scarcely painted at all. A few great figures, Rembrandt above all, excelled at both. There is no guarantee, however, that ability in one medium will lead to success in the other.

Whereas painting is a process of adding coloured pigments to a surface, etching proceeds by the removal of small quantities of wax with a sharp-pointed tool called a needle. These reveal the metal underneath, so that when the plate is placed in acid the lines are eaten into it by the chemical. The rest of the plate's surface, protected by the wax, is unaffected.

So, at the start, there is a metal plate which has been covered with an acid-resistant ground – generally wax – and then blackened, traditionally with smoke from a taper. That was what was leaning on LF's easel. The beginning was, then, a dark, blank oblong on which shiny lines of metal slowly appeared as LF scratched away.

In comparison with painting, which has existed as long as human culture, etching is a relative novelty. It is the product of the Renaissance, an age of technical innovation. Etching is a mixture of artistry and chemistry in which the image is produced by a powerful reaction. From its fierce bath, the etching emerges a different object, and changes once more when the plate is printed – at which point it is, of course, reversed, and also transformed from shiny copper lines on smoked black to black ink on white paper: an almost alchemical metamorphosis.

Etching is a medium that LF came to concentrate on quite late in life; most of his prints date from after he had passed the age of sixty. And he learned, as he tells it, on the job. 'I used to like only the first proof, nothing else, and felt I didn't know what I was doing. But slowly I've found out various things. When I did the head of Bruce Bernard I did the hair by stopping it out, rather than drawing it in, and I thought, Now I'm really etching!' (Stopping-out is a method of letting the acid bite the plate to some extent then covering parts that the artist wants to be lighter with a new layer of wax.)

He didn't want, he says, to do the 'come up and see my etchings sort of etching'. That famous invitation, he feels, was intended to lure the invitee by the driest, dullest bait to the most exciting imaginable possible activity. But LF doesn't want his etchings to be dry or dull – and they aren't. Like his paintings, they are edgy; they have an almost uncomfortable sense of physical proximity.

LF avoided learning certain techniques, such as aquatint – used by Goya – which would have allowed the addition of areas of solid shadow, but prevent the impression he wants his prints to give, as he often says: that the lines work like paint.

This etching of me in fact had an unexpected precedent, rather as the *Man with a Blue Scarf* was descended from the back end of the horse. 'I don't think I would have been able to work on this etching in the way that I am if I hadn't done the last one of the garden. It's more physical – I'm not thinking of the lines as much as of the forms.'

...

The constant ritual of the painting process was the selection and cleaning of brushes and the mixing of the pigments. With etching, it was the sharpening of the tool on a grindstone, five or ten times a session. LF likes to make very fine lines when he etches, and finds the implement – which is like a two-ended bradawl – quickly loses its point.

LF kept his box of etching equipment on an adjustable, red-plush stool – intended to provide some rest while he worked. But instead of sitting, LF remained on his feet, springing backwards and forwards. Like painting, as he practised it etching was a highly physical process, but finer – hence the

necessity for reading spectacles. The donning, removing, losing and finding of those are another part of the ritual.

The experience of sitting for the etching made it clearer to me quite how an artist's studio is a theatre of light. In the original Greek, the word for theatre meant 'a place for viewing'. The spectacle to be viewed was not necessarily a play. Later on, people spoke of operating theatres, in which the patient was displayed, and lecture theatres. In the Renaissance, there was discussion of the 'theatre of memory', in which the contents of the mind were laid out in an imaginary landscape for easy recall.

Of course, 'a place for viewing' is exactly what an artist's studio is. It is a room dedicated to observing an object under carefully controlled conditions. Historically, the development of the artist's studio is all about the provision of light, hence the high windows and the northerly aspect. A northern light provides the steadiest, most reliable illumination: with no disrupting dawn or sunset or confusing differences from morning to afternoon.

Any studio, and certainly LF's, is more like an operating theatre than a playhouse. It is designed so the object to be viewed, in this case me, can be seen as well and, above all, consistently as possible. Thus, the quality and direction of the light are of fundamental importance. The lighting, to a considerable extent, makes the picture. If it alters, so does the image. Just as LF wanted my head at the same angle every time, so – as far as possible – he wanted the light to be the same too. Moving from the front part of the studio, where the night paintings are done, to the back section lit by daylight, had fundamentally altered the rules and the mood of the sittings.

Painters are attuned to light in the way that sailors are to weather, or carpenters to wood. It is what they work with. LF has pronounced tastes in the matter. Personally, but not professionally, he likes it to be changeable.

'My climatic ideal is Dublin weather. I like quickly changing circumstances – it's sunny for ten minutes, then here comes a cloud. For me, a blue sky all day every day would be utterly horrible. But for working, I like a north light that is cold and clear and constant. High, light cloud suits me well. When I read that the studio in Van Gogh's Yellow House faced south, I thought, He really was mad.'

The electric bulb that lit the night portrait, *Man with a Blue Scarf*, had the advantage of being absolutely constant – though LF was concerned about whether or not the door to an adjoining room was open, and the light on next door, because that would slightly alter the play of shadow and reflected light. But the natural light is constantly fluctuating – rising, setting, obscured by overcast sky.

The subtlety of the fall of light, and of the final product, was a constant concern. The sun and state of the sky became a staple topic of conversation. 'This light is lovely!' LF would say enthusiastically. Then, ten minutes later, a cloud would cover the sun, or dusk would start to fall. LF became a dark shape against the window; and he started to have trouble in seeing me. While he was working he stood *contre jour*, looking quite like the image he painted of himself half a century ago in *Hotel Bedroom* (1954).

At first, it seemed that it didn't much matter what I wore, since the etching was obviously not in colour and included little but my face. But after a while he asked me to put on a certain soft, light grey shirt every time, an old one that I had had for at least a decade and whose fabric seemed to absorb the light.

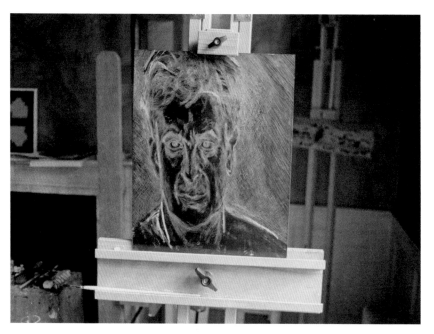

The etching plate, 2005

'If you wear that one it will make it much more subtle.' The nuances of modelling which he was trying to find would have been blocked by a check, or a stripe, or even a stronger grey. The reflectivity of surfaces seems to be of paramount importance when he is etching.

An etching is a bit of a gamble, a fact that may attract LF who used to like a bet. It is hard to tell what the result will be like, for several reasons. One is that the image on the plate is both reversed and negative. What we were looking at on the plate was shiny metallic lines on a black surface. Even LF was not sure what it would look like when it was printed; I had no idea.

An etching is also subject to other unexpected hazards. When I arrived on Monday 20 December there was a series of gashes and gouges on the plate, which had fallen forward off the easel. It must have dropped onto a screw-head protruding from the floor, or something. LF's easels have a tendency to subside of their own accord. Naturally I was worried that the plate was ruined, and all those sittings wasted. But LF said that he could put it right very easily, by stopping-out – that is, adding extra wax – but he had thought that he would wait until I was there before doing anything. 'I've been very lucky with plates, most of them have fallen at one time or another but few have been badly damaged.'

After Christmas I got a call. 'When would you like to work next?' When I suggested after the New Year, there was an audible sound of disappointment in LF's voice. 'What, not for so long?' I agreed to sit on Old Year's Day. By that point I was working intensively every morning on the Van Gogh book – now badly overdue – and I could not get to the studio before one thirty or two. Not long after three o'clock the light started to fade.

On one very dark day, we managed only about half an hour. LF carried on as long as he could – as the completion of a work grows near his urge to carry it forward becomes intense – but he finally gave up, announcing: 'I feel I'm pretending.' Last time, and this too, he ended up doing the ground. 'I can't do you, but I can still do something.'

On one of those dismal days, I suggested turning on a lamp, angled towards the wall on the other side of the room – just enough I thought – to bring up the ambient level so he could see the plate. We tried it, but it wasn't satisfactory. It made, he complained, the bright lines on the plate shine in a distracting way. 'When I'm working I want to think about forms and not to be too conscious of the lines. I want to feel I'm doing a painting.'

By February the etching seemed to be getting quite close to a conclusion. LF was now working on the neck and shirt. One Friday afternoon he put in a couple of jowls I didn't know I had – a discovery reminiscent of Andrew Parker Bowles's dismayed discovery of his stomach protruding from *The Brigadier*.

The sittings became a game of grandmother's footsteps, my attempting to keep my jaw up so as to minimize my jowls or incipient double chin, which I sensed LF was interested in. It was a game I was doomed to lose. At one stage, seeing a fold of sub-chin flesh being chalked in, I raised my head a fraction and, baffled, he rubbed it out.

But at the next sitting, I heard him mutter, 'That's lucky!' I asked what was lucky. 'A form has appeared which I am delineating. It is always there, but it doesn't always show itself. It will help me very much.' It was of course, a little roll of flab. On another occasion, LF remarked *sotto voce* to himself, while

peering hard at the side of my head, 'It really is like that, well, I'll use it!' What he had noticed then, I never found out.

The last session consisted of working all over the plate, lightening and darkening it here and there, 'making it more subtle and more like'. Then finally, after nine months and a quantity of sitting of which I did not even try to keep count, the etching was finally bitten and proofed on the Harrow Road at ten o'clock on Sunday morning, 10 April. The biting of the etching plate in a bath of acid was an extremely tense business, and full of surprises. I arrived with my wife, Josephine, and son, Tom, en route from Dorset, and found Lucian and David already there.

The copper plate, coated with wax, is put in a bath of nitric acid for around forty-five minutes to an hour, the precise point at which it is removed being a matter of fine judgment. At fifteen-minute intervals a timer goes off and the plate is inspected. LF was visibly nervous while this was going on, partly no doubt because on a previous occasion he lost an etching completely when the wax lifted and the acid got underneath. 'As a general rule, I believe that there is no such thing as an accident. I don't mean that in the case of one walking down the street and being hit by something falling on your head. I mean events involving your own volition. But this seems out of my control.'

After the biting of the plate and the removal of the wax, there is no going back. Still, in appearance it seemed much the same as before. The moment of truth comes when the first proof is pulled. That produced an utter transformation. Of course, the shiny metal lines were now black ink, and the image had been reversed (p. 232). But the change was much more fundamental; the image that appeared looked, to me at

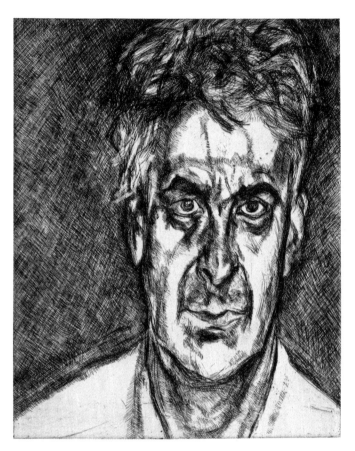

Portrait Head, 2004–05

least, completely new and unexpected. It seemed older, more angst-ridden and also much more sculptural than the plate had ever seemed. At first it was a shock, though after a while I got used to it.

Only now is it possible to see what LF had really been doing for all those months. The little fold of jowl he was so pleased to discover, for example, anchored the head, and stopped it shooting off excessively towards the right-hand top corner. That is, it aided the etching, if not my *amour-propre*.

Furthermore, the three proofs that were pulled seemed to have quite different characteristics. The second, for example, seemed to have less of the forehead, which was because the inking was darker in the background and around the face. After deliberating, LF preferred the first, more even version. He pronounced his verdict: 'I'm pleased with it.'

Then, it being around twelve by now, LF declared, 'I'm going back to work,' and he whisked away – on to the next picture.

June 2005

Both the painting and the etching were included in a big exhibition of LF's work at the Correr Museum, Venice, which coincided with, though it was not actually part of, the Biennale. The owners of *Man with a Blue Scarf,* John and Frances Bowes, came to attend the opening, and I met them at their hotel, the Cipriani, for lunch. My face now played a part in their lives, hanging on the stairs in their house in California. Or, to put it another way, they possessed my alter ego. It was an odd sort of connection, but a convivial occasion. They were pleased with the picture; I was flattered that they liked it.

The two portraits had now begun independent lives on their own in the world. The oil had been on show in the Fogg Art Museum, Harvard, which also has in its collection Van Gogh's *Self Portrait Dedicated to Paul Gauguin* (1888), in which he portrays himself, weirdly but unforgettably, as a Japanese monk: a bonze. While writing my book *The Yellow House,* I had thought about that self portrait again and again, trying to decode its hidden meanings. It is a crucial clue to Vincent's state of mind as he awaited Gauguin's arrival in Arles. Hence, I had probably been thinking about it from time to time as I sat for both the oil and the etching by LF.

It is an aspect of good pictures that it is impossible to memorize them. No matter how well you know them, they always seem different when you see them again (this point has been made to me by apparently very different artists, including Luc Tuymans and Richard Serra, as well as LF). Also, a certain work of art may produce quite different feelings in different people; in fact, it evokes altered responses in the same person at differing times. Indeed, its ability to carry on doing that is one

of the qualities that makes a work of art good. I thought I knew these images as well as anyone could, except their creator. I had watched them grow, week by week, touch by touch. And yet I found that somehow, when I saw them again, they looked new.

The fact that they were on public display was another complication. During the private view in Venice, I was there for quite some time in the room where William Feaver – the curator – had hung the etching and the oil in company with LF's portraits of the Queen, David Hockney and Andrew Parker Bowles. There were many compliments for *Man with a Blue Scarf*, which I scarcely deserved, since I had done nothing more than sit there while it was being painted. There were also quite different reactions. 'It's quite a hot, romantic portrait,' said a prominent dealer – which was gratifying. On the other hand, a painter friend remarked that it reminded him of Théodore Géricault's portraits of the mad – 'those staring eyes' – which was less so.

The etching was less commented on. 'It's harder to get into,' said the director of a national museum. In William Feaver's view it shows I have 'a dark side'. *Portrait Head* is, I think, in a straightforward way, less like me: the face elongated and crumpled as if I had been subject to torsion by the violent forces in the air that seem to swirl around my head (just as in the etching after Chardin). But I accept them both as aspects of myself: the inner and outer self, perhaps.

The painting is a picture of an observer, turned out towards the world positive and interested. In contrast, the etching is a picture of a person caught up in introspection, anxiety, tension and thought. Each in its way is a picture of me, and perhaps – at particular times and in differing circumstances – they reflect two aspects of almost everyone.

SOURCES OF QUOTATIONS

p. 18 'The more our art is serious ...',
*A Free House! Or the Artist as Craftsman,
Being the Writings of Walter Richard
Sickert*, edited by Osbert Sitwell,
London: Macmillan, 1947, p. 208

p. 20 'The aim of linguistic ...',
William Labov, *Sociolinguistic
Patterns*, Philadelphia: University
of Pennsylvania Press, 1972, p. 209

p. 21 'The subject must be kept ...',
Lucian Freud, 'Some Thoughts on
Painting', *Encounter*, vol. 3, no. 1,
July 1954, p. 23

p. 25 'Reader, study the periwinkle ...',
Gaston Bachelard, *The Poetics of Space*,
trans. by Maria Jolas, Boston: Beacon
Press, 1994, p. 155

p. 41 'Character ...', Malcolm Gladwell,
The Tipping Point, London: Abacus,
2001, p. 163

p. 46 'What I'm most ...', *Vincent
van Gogh – The Letters. The Complete
Illustrated and Annotated Edition*, edited
by Leo Jansen, Hans Luijten and Nienke
Bakker, London: Thames & Hudson,
2009, vol. 5, p. 254

p. 48 'alternate abodes for the spirit ...',
James D. Breckenridge, *Likeness: A
Conceptual History of Ancient Portraiture*,
Evanston: Northwestern University
Press, 1968, p. 35

p. 48 'The artist who tries to serve ...',
Lucian Freud, op. cit., p. 24

p. 58 'Bacon hit ...', David Sylvester,
*About Modern Art: Critical Essays,
1948–96*, London: Chatto & Windus,
1996, p. 319

p. 61 'They were both dressed ...',
Stephen Spender, *Journals 1939–1983*,
London: Faber & Faber, 1985, p. 158

p. 74 'the eyes ...', Charles Darwin,
*The Expression of the Emotions in Man
and Animals*, Chicago: University of
Chicago Press, 1965, p. 289

p. 79 'First I start ...', *Vincent van Gogh
– The Letters*, op. cit., vol. 4, p. 132

p. 93 'a preternatural sum ...', Daniel
McNeill, *The Face*, London: Hamish
Hamilton, 1999, p. 84

p. 107 'People don't know ...', Henry
Mayhew, *London Labour and the London
Poor*, vol. 3, London: Griffin, Bohn,
1861, p. 209

p. 108 'the picture ...', Lucian Freud,
op. cit., p. 23

pp. 111–12 'It coagulated in little lumps
...' and 'I know my idea ...', Lawrence
Gowing, *Lucian Freud*, London: Thames
& Hudson, 1982, pp. 190–91

p. 137 'In nature ...', Medardo Rosso in
a letter to Edmond Claris, quoted in
Caroline Tisdall and Angelo Bozzolla,
Futurism, London: Thames & Hudson,
1977, p. 27

p. 164 'driven across the surface ...',
Lawrence Gowing, op. cit., p. 118.

p. 167 'Like most muscles ...' Daniel
McNeill, op. cit., p. 178

p. 171 'Sir! you have ...', Hilaire Belloc,
*Cautionary Tales for Children: Designed
for the Admonition of Children Between
the Ages of Eight and Fourteen Years*,
London: Eveleigh Nash, 1908, p. 51

p. 181 'Staring is special ...', Daniel
McNeill, op. cit., p. 228

p. 182 'habit of long and continuous ...',
Marina Sabinina, quoted in Alex Ross,
*The Rest is Noise: Listening to the
Twentieth Century*, London: Fourth
Estate, 2008, p. 258

FURTHER READING

Bernard, Bruce, and Derek Birdsall (eds), *Lucian Freud*, London: Jonathan Cape, 1996

Calvocoressi, Richard, *Early Works: Lucian Freud* (exh. cat.), Edinburgh: Scottish National Gallery of Modern Art, 1997

Feaver, William, *Lucian Freud* (exh. cat.), London: Tate Publishing, 2002

—, *Lucian Freud*, New York: Rizzoli, 2007

Figura, Starr (ed.), *Lucian Freud: The Painter's Etchings*, New York: Museum of Modern Art, 2008

Freud, Lucian, *Freud at Work: Photographs by Bruce Bernard and David Dawson*, Lucian Freud in conversation with Sebastian Smee, London: Jonathan Cape, 2006

—, *Lucian Freud, 1996-2005*, with an introduction by Sebastian Smee, London: Jonathan Cape, 2005

—, *Lucian Freud on Paper*, with an essay by Richard Calvocoressi and an introduction by Sebastian Smee, London: Jonathan Cape, 2008

Gowing, Lawrence, *Lucian Freud*, London: Thames & Hudson, 1982

Hartley, Craig, *The Etchings of Lucian Freud: A Catalogue Raisonné 1946–1995*, London: Marlborough Graphics, 1995

—, *Lucian Freud: Etchings 1946–2004* (exh. cat.), Edinburgh: National Galleries of Scotland, 2004

Lampert, Catherine, *Lucian Freud* (exh. cat.), with an essay by Martin Gayford and an introduction by Frank Paul, Dublin: Irish Museum of Modern Art, 2007

LIST OF ILLUSTRATIONS

Measurements are given in centimetres, followed by inches, height before width
LFA/John Riddy = Lucian Freud Archive: photography by John Riddy

p. 60 *Boy Smoking*, 1950–51. Oil on copper, 20.4 × 165 (8 × 65) Tate. LFA/John Riddy

p. 62 *A Man and His Daughter*, 1963–64. Oil on canvas, 61 × 61 (24 × 24). Private collection. LFA/John Riddy

p. 67 Caravaggio, *Conversion of St Paul*, 1600–01. Oil on panel, 237 × 189 (93¼ × 74⅜). Church of Santa Maria del Popolo, Rome

p. 70 *Double Portrait*, 1985–86. Oil on canvas, 79 × 89 (31⅛ × 35). Private collection. LFA/John Riddy

p. 71 *The Painter's Mother Resting, I*, 1976. Oil on canvas, 91 × 91 (35⅞ × 35⅞). Private collection. LFA/John Riddy

p. 78 *Self Portrait, Reflection* (work in progress) 2004. Photograph by David Dawson

p. 80 Jean-Siméon Chardin, *Self Portrait*, 1771. Pastel on paper, 46 × 37.5 (18⅛ × 14¾). Musée du Louvre, Paris

p. 84 *Self Portrait, Reflection*, 2002. Oil on canvas, 66 × 50.8 (26 × 20). Private collection. LFA/John Riddy

p. 87 Francisco de Goya, *El Lazarillo de Tormes*, 1808–12. Oil on canvas, 80 × 65 (31½ × 25⅝). Private collection, Madrid

p. 89 *The Painter's Room*, 1943–44. Oil on canvas, 63.1 × 76.1 (24⅞ × 30) Private collection/Bridgeman Art Library

p. 98 *John Deakin*, 1963–64. Oil on canvas, 30.2 × 24.8 (11⅞ × 9¾). Private collection. LFA/John Riddy

p. 102 Girl posing for the etching, *Girl with Fuzzy Hair*, 2003. Photograph by David Dawson

p. 103 *Girl with Fuzzy Hair*, 2004. Etching, 65.7 × 49.8 (25⅞ × 19⅝). LFA/John Riddy

p. 110 The studio in Holland Park, 2004. Photograph by David Dawson

p. 117 *John Minton*, 1952. Oil on canvas, 40 × 25.4 (15¾ × 10). Royal College of Art, London. LFA/John Riddy

p. 120 *Man in a Blue Shirt*, 1965. Oil on canvas 59.7 × 59.7 (23½ × 23½). Private collection. LFA/John Riddy

p. 123 Titian, *Diana and Actaeon*, 1556–59. Oil on canvas, 198 × 206 (77 × 81⅛). National Gallery of Scotland, Edinburgh

p. 126 *Old Man, after El Greco's St Philip*, no. 4 in the 1940 Sketchbook. Ink, 21.3 × 14.6 (8⅜ × 5¾). Private collection. LFA/John Riddy

p. 138 *Pluto's Grave* (work in progress), 2003. Photograph by David Dawson

p. 140 *Pluto's Grave*, 2003. Oil on canvas, 41 × 29.8 (16⅛ × 11¾). Private collection. LFA/John Riddy

p. 143 *David Hockney and Lucian Freud*, 2003. Photograph by David Dawson

p. 144 *David Hockney*, 2003. Oil on canvas, 40.6 × 31.1 (16 × 12¼). Private collection. LFA/John Riddy

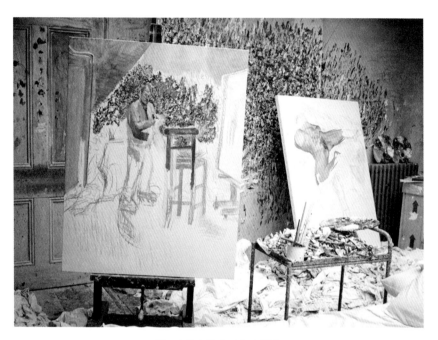

The studio in Holland Park, 2004

p. 148 *Self Portrait, Reflection*, 2003–04. Oil on canvas, 17.8 × 12.7 (7 × 5). Private collection. LFA/John Riddy

p. 150 *David and Eli*, 2003–04. Oil on canvas, 162.5 × 174 (64 × 68½). Private collection. LFA/John Riddy

p. 158 *Large Head*, 1993. Etching, 69.4 × 54 (27⅜ × 21¼). LFA/John Riddy

p. 160 *Armchair by the Fireplace*, 1997. Oil on canvas, 66 × 56 (26 × 22). Private collection. LFA/John Riddy

p. 162 Lucian Freud and Andrew Parker Bowles, 2003. Photograph by David Dawson

p. 165 *The Brigadier*, 2003–04. Oil on canvas, 223 × 138.4 (87¾ × 54½). Private collection. LFA/John Riddy

p. 166 Lucian Freud, 2005. Photograph by David Dawson

p. 186 Jean-Siméon Chardin, *The Young Schoolmistress*, 1735–36. Oil on canvas, 61.6 × 66.7 (24¼ × 26¼). National Gallery, London

p. 187 *After Chardin*, 2000. Etching, 59.5 × 73.3 (23⅜ × 28⅞). LFA/John Riddy

p.193 *Naked Portrait*, 2004. Oil on canvas, 121.9 × 101.6 (48 × 40) Private collection. LFA/John Riddy

p. 195 *Self Portrait* (unfinished), 1952. Oil on copper, 12.8 × 10.2 (5 × 4). Private collection/Bridgeman Art Library

p. 196 *After Chardin*, 2000. Etching, 15.4 × 20.1 (6 × 7⅞)

p. 201 Paul Gauguin, *The Painter of Sunflowers*, 1888. Oil on canvas, 73 × 92 (28¾ × 36¼). Van Gogh Museum, Amsterdam (Vincent van Gogh Foundation)

p. 203 *Pluto Aged Twelve*, 2000. Etching, 43.5 × 59.7 (171⅛ × 23½). LFA/John Riddy

p. 204 *Lucian Freud with a fox*, 2005. Photograph by David Dawson

p.206 *Lobster*, 1944. Conté and crayon, 65 × 83 (25⅝ × 32⅝). Private collection. LFA/John Riddy

p. 217 Lucian Freud, *Man with a Blue Scarf* and Martin Gayford, 14 June 2004. Photograph by David Dawson

p. 218 *Man with a Blue Scarf*, 2004. Oil on canvas, 66 × 50.8 (26 × 20). Private collection. LFA/John Riddy

p. 222 Martin Gayford and Lucian Freud, 2005. Photograph by David Dawson

p. 228 The etching plate, 2005. Photograph by David Dawson

p. 232 *Portrait Head*, 2004–05. Etching, 40 × 31.8 (15¾ × 12½). LFA/John Riddy

p. 240 The studio in Holland Park, 2004. Photograph by David Dawson

p. 248 Eli, 2002. Photograph by David Dawson

ACKNOWLEDGMENTS

I am obviously most grateful to Lucian Freud, for the many hundreds of fascinating hours I have spent in his company – every one enlightening – for transforming me into two very different works of art, and for encouraging me to write this book. David Dawson, too, has been wonderfully enthusiastic and helpful throughout the gestation of the project. He read my words, made helpful suggestions and generously agreed to the inclusion of his beautiful photographs – which add an additional dimension, I think, to the final publication. John Riddy has provided superbly accurate photographs of Lucian's works and Diana Rawstron was a source of ready help and advice.

It has been a pleasure to work with the team at Thames & Hudson. Thanks to my agent, David Godwin, and my wife, both of whom read the manuscript and proposed improvements. Thanks also to editors who first commissioned me to write about the process of sitting, in particular Michael Hall at *Apollo*, Sarah Crompton and Tom Horan at the *Daily Telegraph* and Karen Wright of *Modern Painters*. Some reflections, incidents and exchanges recounted in those publications have found their way into the book. My son, Tom, compiled the index and pointed out several glitches while doing so. He was pleased with the entry 'eggs, personalities of', which may indeed be unique in the history of indexing.

INDEX

Page numbers in *italic* refer to illustrations

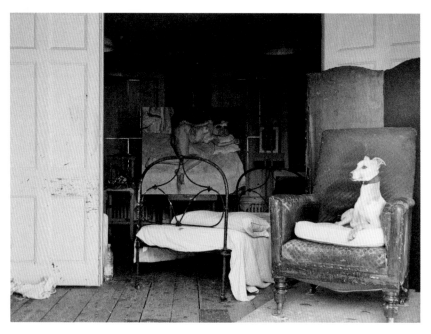

Eli, 2002